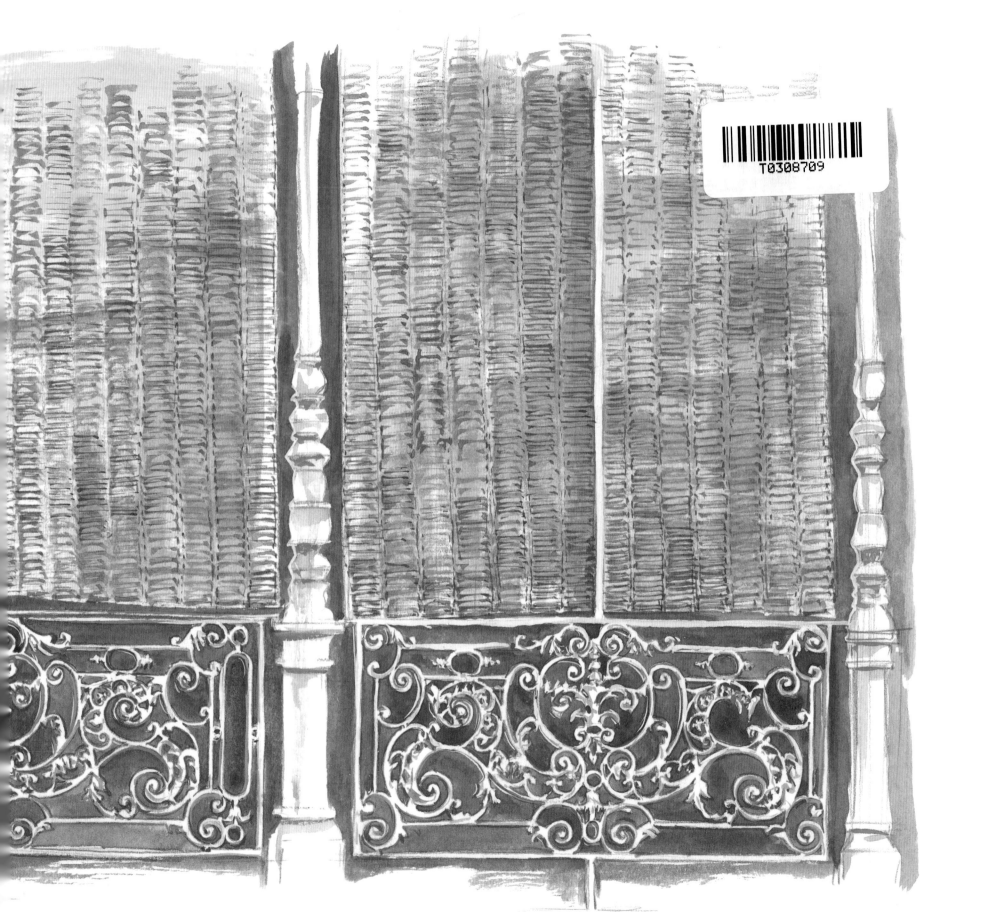
T0308709

Mauritius

Sketchbook

Artist's dedication
to Étienne

Paintings © Sophie Ladame 2004
Text and captions © Yvan Martial 2004
Design and typography © Éditions Didier Millet 2004

Text and captions translated from French by Cheryl A. Newman
Handwriting by Anita Ryanto

Editorial Director: Timothy Auger
Editor: Gwenaëlle Solignac
Designer: Yolande Lim
Production Manager: Annie Teo

First published in English in 2004 by Archipelago Press,
an imprint of
Editions Didier Millet
78 Jalan Hitam Manis
Singapore 278488
www.edmbooks.com

Reprinted in 2011, 2019

All rights reserved. No part of this publication may be reproduced, stored in a retrieval system
or transmitted in any form or by any means without written permission from the publisher.

Colour separation by Sang Choy, Singapore
Printed in Malaysia by TWP Sdn Bhd

First published in French as *Île Maurice aquarelles* by
Les Éditions du Pacifique, 5 rue Saint-Romain, 75006 Paris

ISBN: 978-981-4155-16-8

The production of *Mauritius Sketchbook* has been made possible by the generous support of:

GENERAL CONSTRUCTION CO. LTD

STATE INVESTMENT CORPORATION

Mauritius
Sketchbook

Paintings by Sophie Ladame Text by Yvan Martial

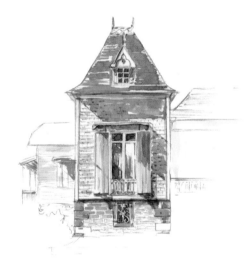

edm EDITIONS DIDIER MILLET

Mauritius

Afrique

Madagascar
Mauritius
La Réunion

Rodrigues

600 km

N

Île Plate
Île Gabriel

Coin-de-Mire · Cap-Malheureux
Pointe-aux-Canonniers · Grand-Gaube
Grand-Baie

Poudre-d'Or
Pointe-aux-Piments
Pamplemousses
Baie-du-Tombeau · Montagne-Longue
Poste-de-Flacq
Port-Louis
Beau Bassin · Réduit
Centre-de-Flacq
Rose Hill
Belle-Mare · Trou-d'Eau-Douce
Flic-en-Flac
Bel-Air
Vacoas
Curepipe
Tamarin
Île-aux-Cerfs
Rivière-Noire
Grand-Port

Morne Brabant
Mahébourg
Indian Ocean
Baie-du-Cap
Blue Bay
Souillac

Contents

Introduction

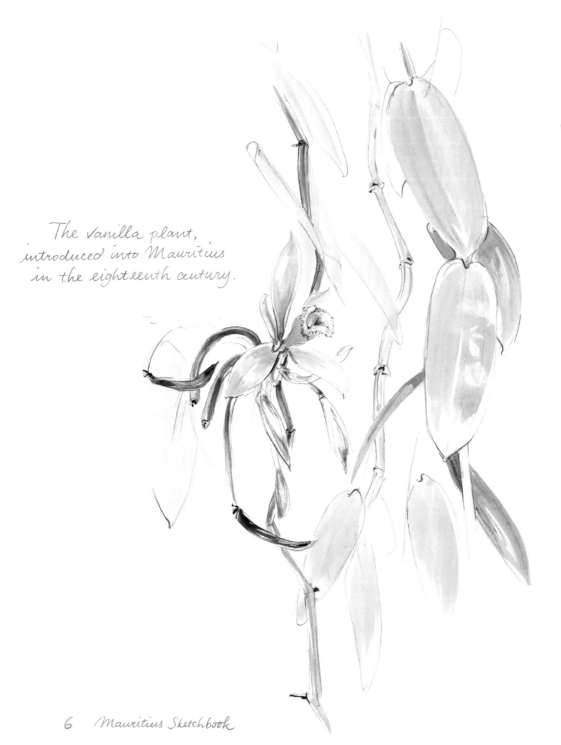

The vanilla plant, introduced into Mauritius in the eighteenth century.

If you weren't born and bred here, you might find the Mauritians' fierce attachment to their tiny island homeland a bit puzzling. But, if you do find yourself shaking your head at their enthusiasm, remember that you are not the first. In the late 1890's, in *Following the Equator*, Mark Twain wrote, 'You gather the idea that Mauritius was made first, and then heaven; and that heaven was copied after Mauritius.' With his wry sense of humour he was, in fact, poking fun at the islanders' self-satisfaction. But in the many years since Mark Twain's visit, Mauritians have dropped the first part of his remark, and quote only the second half – crediting Twain with an accolade rather than the acerbic comment intended. We should pardon the Mauritians for being keen to promote themselves though, for their island is conspicuously small: at 1865 square kilometres (720 square miles) it is a mere speck in the middle of the ocean. While many Mauritians are remarkably content to remain on their beloved island, there are those who leave to travel and live abroad. Yet, when they return to their 'pearl of the Indian Ocean', they gaze again on turquoise lagoons, a sapphire sea, the glistening white reefs and fine sandy beaches, the aquamarine and amethyst-coloured mountains and jade-hued sugar-cane fields. Little wonder that the rest of the world's splendours pale in comparison.

Their desire to leave and their delight upon return are not really the paradox they seem. Though deeply rooted in the island soil, many Mauritians keep alive gentle dreams of the 'old

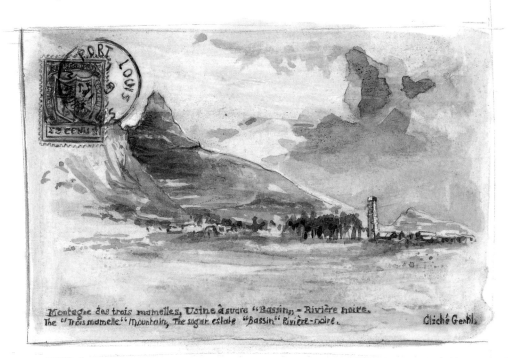

The Trois-Mamelles mountain. In the foreground, the former sugar factory at Bassin Lake, destroyed by a terrible cyclone on 29 April 1892.

Montagne des trois mamelles, Usine à sucre "Bassin" – Rivière noire.
The "Trois mamelle" Mountain, The sugar estate "Bassin" Rivière-noire. Cliché Gentil.

country', whether that was France or elsewhere in Europe, or perhaps Madagascar, Africa, India or China. People have been migrating to Mauritius for hundreds of years now, and so those dreams may have been filtered through the mists of time. To ancestral attachments the Mauritian adds deeply held religious convictions. Among Mauritians, you will find followers of many of the world's principal faiths, including Christianity, Hinduism, Islam and Buddhism. Far removed from the conflicts of the rest of the world, Mauritians have successfully managed to nurture their individual ancestral traditions, while ensuring that their personal religious and cultural practices don't conflict with those of others. Mauritius has no monopoly on beautiful beaches and magnificent vistas. Lovely indeed, but perhaps even the most casual visitor will most appreciate the calm and harmonious existence Mauritians have created on their intensely populated island (650 inhabitants per square kilometre/1684 people per square mile). Mauritians have enjoyed racial, cultural and religious harmony for many years, and the passage of time only seems to make it better.

Setting aside ancient conflicts, Mauritians of all ages and at every level of society meet, work together, create warm relation-ships and marry. What in other countries are obstacles to peace – race, social and cultural traditions – are for the Mauritians sources of mutual enrichment. In Mauritius, the visitor will find a comforting new image of mankind, richer and more neighbourly because it successfully blends so many cultures.

Geographically, Mauritius resembles a half-circle, with a gentle bulge at the mid-point. The central highlands, rising to 600 metres (1968 feet) above sea level, occupy much of the interior and descend gradually to the coastal plains. The highlands sit within the remains of an ancient volcanic cone. The dazzling ballet between the lava flow and surrounding hills (adored by the philosopher Malcolm de Chazal) and the indigenous flora and fauna, Eden-like countryside, coral reefs, transparent lagoons, and fine white sand are evidence of the island's formation some eight million years ago. Mauritius contains numerous micro-climates. To the north are vast sugar-cane fields where the only landmark is Coin-de-Mire, an ancient mountain peak which seems to rise from the open sea. The Moka

range is easily identified thanks to its three summits: the Pieter-Both, the Pouce (Thumb) and the Signaux (Signal Mountain), which separate the northern and southern parts of the island.

The eastern plains climb gently toward the central highlands. The Moka range to the north, and the Grand-Port mountains to the south create a sort of geological wedge orientated towards the highlands. From the south, undulating plains climb towards the highlands, culminating in the Grand-Port mountains and the Black River mountain to the west. This region, as well as the eastern plains and the highlands, are the wettest parts of the island. Refreshing southeast trade winds sweep these districts, also bringing much-needed rain. At its southern tip the island culminates in severe basalt cliffs before falling away to the vast and tumultuous sea.

The western plains are narrow and elongated. Spanning the island between the southern and northern shores, they offer beautiful coastal routes between sea and mountain, as appealing as those of the southwestern and southeastern coasts.

Access to the central highlands was nearly impossible until 1864. It was only then that the development of a new railway line put Mahébourg, on the east coast, by train within two hours of Port-Louis, on the northwest coast. Earlier travellers had faced a journey of twenty-four hours by foot or twelve hours by horse or

Les Aubineaux, former home of the Guimbeau family. Near Forest Side, Curepipe, it is now the Musée du Vieux-Curepipe, and the first stage on the Tea Route. During the second half of the nineteenth century well-to-do families preferred to live in the healthier highlands, instead of the coastal regions which were infested by malaria-carrying mosquitoes.

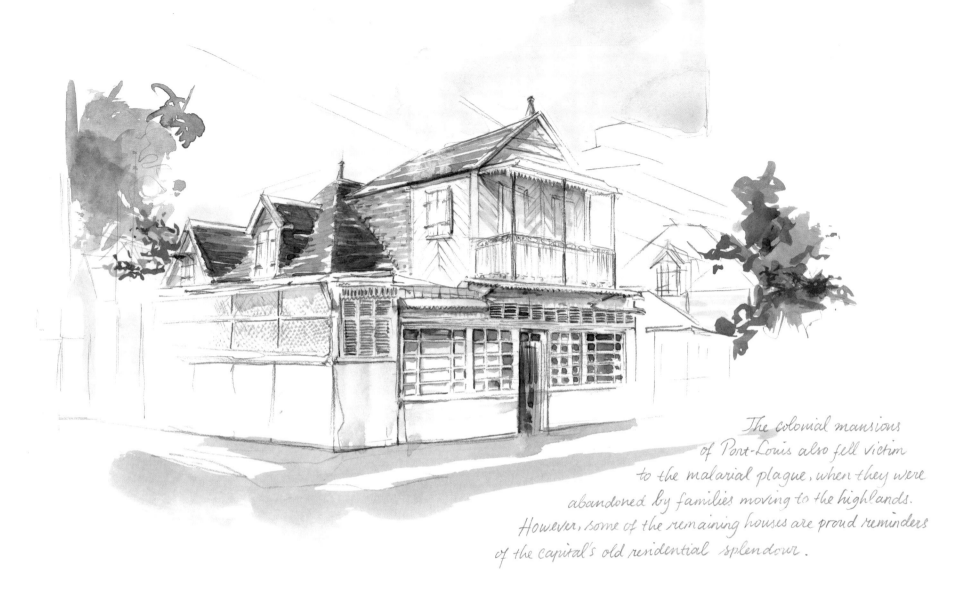

The colonial mansions
of Port-Louis also fell victim
to the malarial plague, when they were
abandoned by families moving to the highlands.
However, some of the remaining houses are proud reminders
of the capital's old residential splendour.

stagecoach to make the same trip. The central highlands were an almost impenetrable forest, a sanctuary for runaway slaves, a 'Réduit' (Retreat) for the governor and the women of the colony in the event of enemy invasion, and a habitable frontier for hardier colonists. The future would prove these colonists right, for the next century saw surging population growth in the highlands, driven by agricultural workers coming to work in the local sugar industry and necessitated by the appearance of previously unknown diseases, among which malaria proved the deadliest. Successive, devastating epidemics forced wealthy lowland families, who had no cure for the unknown fevers, to join the frontier colonists and migrate towards the healthier climate of the highlands, despite the dual risks of drought and torrential rains.

A safe maritime route through the Indian Ocean seemed an unattainable goal during the early years of ocean-going exploration. Only in 1487 did the daring Portuguese explorer Bartholomeu Diaz discover and safely circumnavigate Cape

The Boucle d'Oreille or 'Trochetia boutoniana',
the national flower of the Republic of Mauritius.
This endemic shrub, found only in Morne Brabant,
was discovered in 1973 by Joseph Guédo.

Storm, now known as the Cape of Good Hope. Ten years later, he was followed by his countryman and fellow adventurer Vasco da Gama. Despite their successful passage of Cape Storm, it was still considered prudent to sail close to the east African coast through the early decades of the sixteenth century. Thanks to the Portugese explorers though, the sixteenth century closed with a great outburst of naval activity, as nations eager for commerce in the East finally began to appreciate the value of a direct link between the oceans, putting the seas of the Mascarene Basin within reach.

Some historians attribute Mauritius' discovery to Diego Diaz, Bartholomeu's brother. Others credit Don Diego Fernandez Pereira, who may have sighted the island in February 1507, or perhaps Domingo Fernandez, the first European known to have disembarked at Mauritius, in December 1511. Diego Rodriguez landed on the tiny island now bearing his name in February 1528. Mauritius, with la Réunion, Rodrigues, and the Cargados Carajos archipelago, were part of the Mascarene Islands, named for the navigator and soldier Pedro Mascarenhas, although there is no extant documentation establishing that he ever visited the islands that bear his name. Traditionally, Mauritius's discovery is also linked to a Portuguese ship who seems to have been named

Cirne (Swan), another early name for Mauritius. Again, no documents are available to prove this claim. It's quite possible that Mauritius was first named Swan Island because of some confusion over an unusual bird that was found there by early explorers. Perhaps those first visitors saw the dodo and mistook it for a swan (although that is a bit far-fetched, as they do not look at all alike). It woud certainly explain, though, how Mauritius might once have been known as Swan Island.

The Portuguese left remarkably few physical signs of their passage. But, we do find plenty of Portuguese place names on charts and maps for the islands they touched in their explorations. Today these include: Rodrigues (from Diego Rodriguez), Agaléga (from Galicia, home of Juan de Nova), the Chagos archipelago including Diego Garcia, and the Cargados Carajos archipelago, which is also known as the Saint-Brandon (Sao Brandao) archipelago and also as the Saya de Malha shoal. The Portuguese remained masters of the Indian Ocean until the English defeated Philip II's Spanish Armada in 1588.

The Dutch were the first to encroach on the former Portuguese seas. On 20 September 1598, under the command of Admiral Wybrandt Warwijck, the Dutch took possession of the Ilho do Cirné (Swan Island), and renamed it Mauritius in honour of their *stadhouder*, or chief of state, Prince Maurice of Nassau. They disembarked at Grand-Port, preferring that to other moorings they had explored, notably Black River to the west and Grande-Rivière and Port-Louis to the north-west. In 1606 the Dutch

put ashore twelve dozen goats and a dozen pigs and sows, all of which quickly began to reproduce. The domestic pigs quickly reverted to a feral state, and even today possess characteristics such as the broad shoulders and an aggressive nature that are closer to that of the wild boar than the farm pig. The industrious Dutch also planted fruit trees along the riverbanks. They discovered some of the most interesting natural resources of the island: giant tortoises, the palm-cabbage, a high-quality ebony tree, and of course, the dodo, which was subjected to a total massacre. The dodo (*Columbina* order and *Raphides* family) was given the scientific name *Raphus cuculatus*, meaning silly or inept. And indeed, the dodo was nature's dunce. Lacking any predators, it had completely lost the ability to defend itself, including the ability to fly. The Dutch trapped, killed and ate the dodos as quickly as they could capture the defenceless, doddering birds. In less than 100 years, the dodo, found only on

Pointe-des-Régates has long been a favorite spot for Mauritians. In the nineteenth century it was a very busy public promenade, especially during sailing regattas. In December 1899, a monument was built honouring sailors and soldiers killed in the August 1810 naval battle of Grand-Port, fought between the English and French. Pointe-des-Régates is now part of the seafront at Mahébourg.

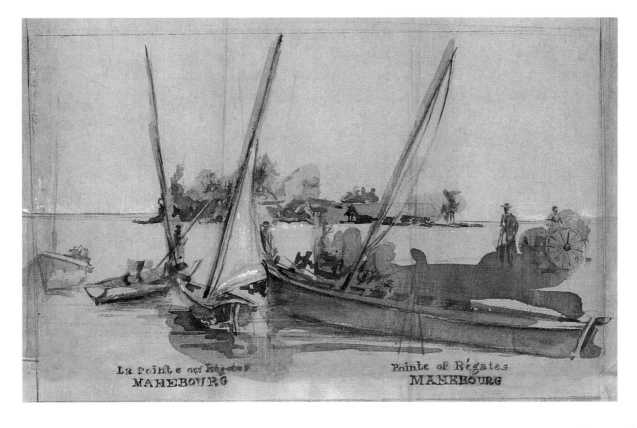

La Pointe des Régates MAHEBOURG

Pointe of Régates MAHEBOURG

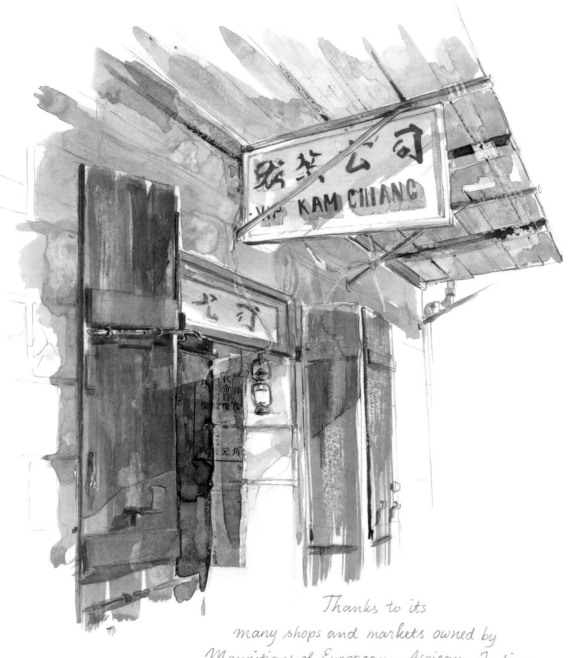

Thanks to its many shops and markets owned by Mauritians of European, African, Indian, Pakistani, Chinese and Madagascan origin, Port-Louis offers visitors a vast choice of imported products.

the island of Mauritius, was on a one-way road to extinction. Its cousins, the dronte of la Réunion and the solitaire or flightless ibis of Rodrigues, were also imperilled. The precious ebony tree faced the same unlucky fate. No sooner had directors of the Dutch East India Company received their first specimen of this 'beautiful tar-black' tree, than they began to cut them all down. The ebony tree forests of Mauritius were soon devastated.

Beginning in 1638, the Dutch made a tremendous but ultimately unsuccessful effort to occupy and colonize Mauritius. The reasons they failed were many: not enough people, too few resources, little contact with decision-makers in Amsterdam or the Cape of Good Hope, little agreement among the colonists, and no real authority or leadership. The Dutch leadership agreed on almost nothing with the colonists, expecting them to go along with all the Dutch plans. Before giving up on their venture though, the Dutch introduced many plants which would prove to be vital to Mauritius, including sugar cane in 1639. During the same period, Governor Van der Stel introduced rabbits, sheep, geese, ducks, pigeons, and the Java deer to the island. An active slave trade developed, as imported slaves were used to accomplish the heavy tasks of colonizing and taming the island. Embittered by their inhumane treatment, some slaves escaped into the woods, and attacked their former masters whenever the opportunity arose. All these elements – the fugitive slaves, the menacing annual cyclones, the damage caused to the new plantation growth by macaque monkeys and rats, and the

general difficulty of colonizing an island thousands of miles from home – led to the final departure of the Dutch in 1710. Many of the place names originally given by the Dutch remain, including Flacq (the flat country), Flic-en-Flac (from *Fried Landt Flaak*, or free flat land), Pamplemousses (or grapefruit, from *pompelmoes*, combining *pompoen* – pumpkin and *limoes* – lemon), and Pieter-Both mountain, the name of the governor general of the Netherlands Indies, who perished in the shipwreck of the *Benda* in the seas off Flic-en-Flac, in February 1615.

The French, arriving in 1721, ran into many of the same problems, and their efforts at colonization began with almost as little success as the Dutch. Then Mahé de La Bourdonnais was in charge of the first French attempt at colonization. The 'grocers of Paris', as the Directors of the French East India Company were known, gave La Bourdonnais the necessary resources to transform the Isle de France (Mauritius's third official name) into a fortified and provisioned way station on the approach to the Indian Ocean. Upon his arrival in 1735, the island was nearly pristine. At his departure in 1747, he was leaving behind a civilization carved from the wilderness. He had constructed a city with well-marked streets, a Government House and a fortified space for workshops and organizations of all kinds. He provided a decisive catalyst for the early sugar industry, investing in the building of two factories: Villebague in the north, and at Ferney, Grand-Port. On 17 and 18 August 1744, the shipwreck of the Saint-Géran released into the waves a cargo of machinery pieces

destined for the sugar factory at Villebague. This event inspired the novelist Bernardin de Saint-Pierre to write his tragic love story, *Paul and Virginie*. La Bourdonnais was also instrumental in developing the road system, planning the routes from Port-Louis to Moka and Pamplemousses. He was responsible for creating the original estate of Mon Plaisir, which would later become the Pamplemousses Botanic Garden, under the strict guidance of its first two administrators, Pierre Poivre and Nicolas Céré. The

A shadow-play of blues on simple corrugated sheet metal creates a soothing symphony of colour.

Luminous patterns at play on a silk sari.

historian Auguste Toussaint wrote about La Bourdonnais, 'Few builders have done better in such a short time and with so little means.' If Mauritius was not built by La Bourdonnais alone, it was he who inspired a spirit of Mauritian enterprise that has diminished little since those early years. Since the time of La Bourdonnais, generations of Mauritians have cherished a desire for progress, a commitment never to rest on their accomplishments, and an abiding concern to pass on to future generations a stronger, more sympathetic, more humane Mauritius. Business people and their employees, first families and new immigrants, are captivated by the desire to build a country with a responsible government, and political and economic independence. Visitors to this remote island nation will find its

citizens engaged in both dialogue and action to build a better future for Mauritius. That constant, voluntary improvement is even more remarkable because it is the effort of a heterogeneous population, coming from many continents (Europe, Africa, Asia), belonging to different religions (Christian, animist, Hindu, Islam, Buddhist), speaking different languages (French, English, many African languages, Hindi, Tamil, Marathi, Bhojpuri, Urdu, Chinese, Cantonese). Over time, through linguistic crossbreeding, these different languages evolved into Mauritian Creole, a common language that combines syntactical elements from one or another of the numerous mother languages with vocabulary from all of them.

Intimately associated with the Creole language and culture, *séga* is a form of both dance and song, characterized by a forceful, pounding rhythm. Today, it has gained in universality while retaining much of its African originality. Over time *séga* has been married with more varied rhythms, adding musical nuances from other continents, without losing its original energy. Years ago, you could hear *séga* music mainly in districts where daily life followed African customs. Today, its pulse resonates in up-market living rooms, smart mansions, conservative gatherings, weddings, and official ceremonies. Once condemned by prudish missionaries for lasciviousness and obscenity, *séga* today happily lends its infectious melody to joyous hymns sung by parishioners in packed churches. Mauritian Creole, once a symbol of Africa, of a 'creolization' which alarmed Mauritians of Indian descent who

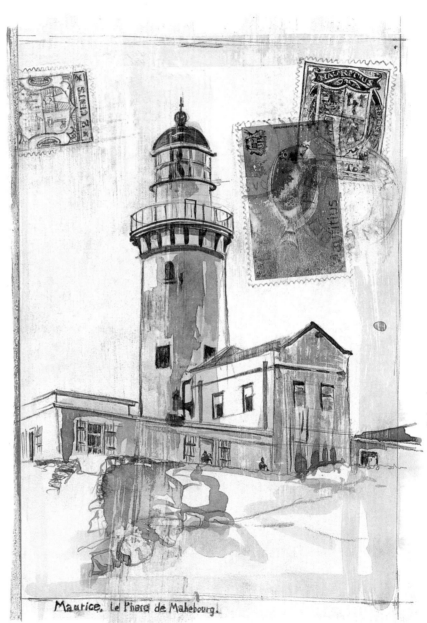

Maurice, Le Phare de Mahebourg.

were strongly attached to their ancestral values, today helps diffuse cultural tension and reverse secular partitions, and provides a common language for young Mauritians eager to share their island home together. Creole, once feared by academic authorities who saw it only as an obstacle to learning the other languages spoken on the island, is now spoken where professors gather, by boards of directors, at meetings of bureaucrats, government assemblies, political meetings, and in classrooms.

Mauritians are all immigrants, even if they did not all arrive on the same boat. They needed many strong arms, hard work, and sweat to clear thousands of hectares of land for planting, transforming it into fields of sugar cane and tons of brown sugar.

In the beginning there were colonists, principally French, who came to populate the island that La Bourdonnais had dreamed of making the star of the Indian Ocean. Those first small steps enticed others to follow. Entrepreneurial British families arrived, to found the principal commercial enterprises on Mauritius.

You still find that entrepreneurial spirit today, in confident foreigners who invest their money in Mauritius, and come to find that they too, are part of Mauritius. These economic activities, first 100% agricultural, then gradually becoming commercial, financial, industrial, tourist-based, and high-tech, continue to require a healthy and growing population.

Before 1835, the solution was slaves and slave trafficking. But the arrival of the British and consequent abolitionist pressure led to the emancipation of approximately 70,000 slaves. Even

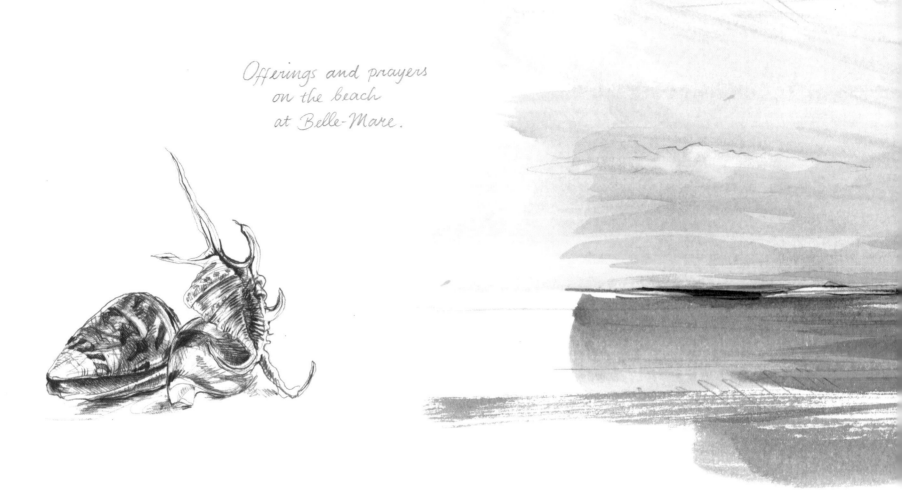

Offerings and prayers
on the beach
at Belle-Mare.

before they were freed, the slaves had been replaced by migrant workers, hired in India and put to work in the sugar industry. Some emancipated slaves returned to their homelands, but others renewed their contracts and today their descendants are citizens of a country that has become their own.

Indian immigration lasted for a century. Between 1830 and 1924 over 500,000 Indians arrived, following the Tamil artisans recruited by La Bourdonnais and his successors. Although the majority of both groups were Hindus, one out of five immigrants from the Indian subcontinent was Muslim. Others decided to come as migrants: jewellers, Tamil farmers, and Muslim merchants. The Chinese did the same, many despite a deep cultural belief that prohibited trying to better themselves in this

life. History proved them right, as the Chinese immigrants thrived in Mauritius. Affinity to one's ancestral roots is an affair of the heart, and not linked to a visa or a stamp in a passport. The people who live on Mauritius are proof that you can consider yourself European, African, Indian, or Chinese, and fiercely guard those traditions, yet also maintain wholeheartedly that you are a proud citizen of Mauritius. Similarly, Mauritians who emigrate to other countries refuse to cut the cord that ties them to the island of their birth.

Let's follow in the footsteps of the immigrants who came to settle Mauritius, and visit the island beginning with the first places where they first set up home: the East, Port-Louis, the North, the South and the West, and the Centre. Then we'll explore Rodrigues.

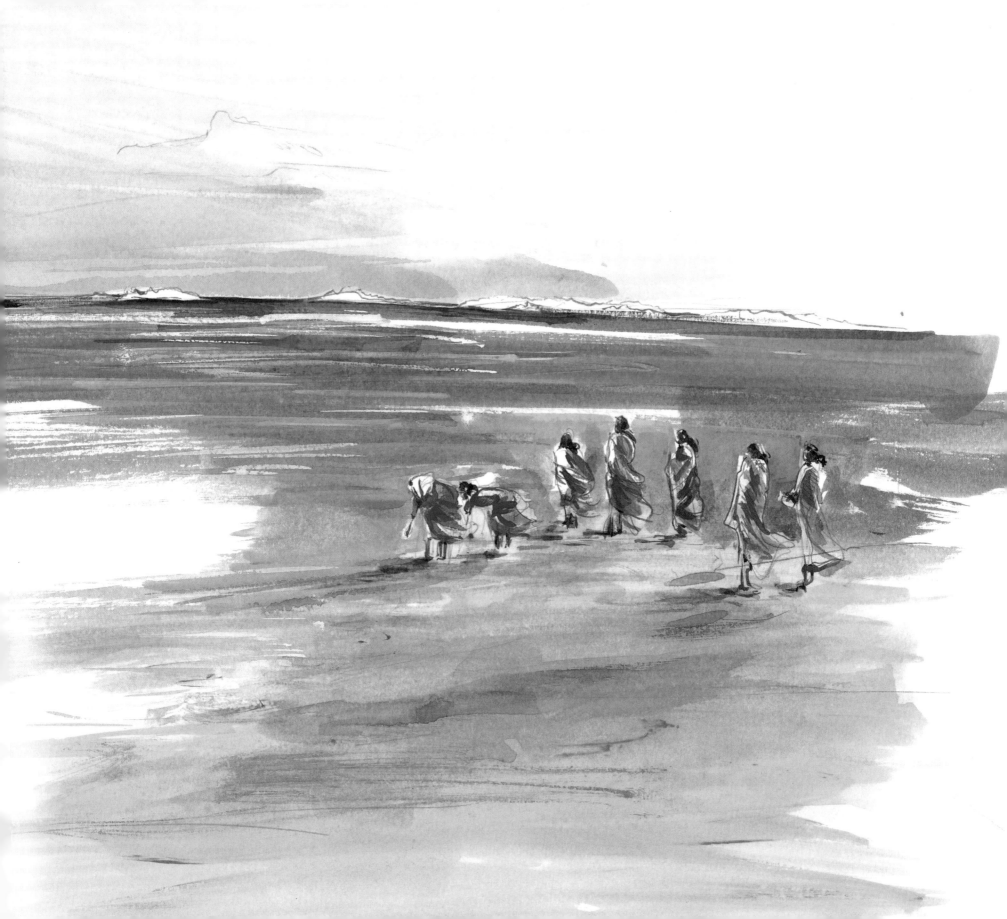

The East

Governor Antoine Marie Desforges-Boucher, who ruled Mauritius from 1759 to 1767, described the island as 'impossible to defend'. There were just too many harbours and other natural anchorages. Grand-Port, to the southeast, is a perfect example. Two natural inlets allowed for an easy entrance to the harbour, but egress proved more challenging. Before the advent of the steamship, sailing ships leaving Grand-Port fought both headwinds and the trade winds that blow from the southeast ten months out of twelve. The French preferred the harbour at Port-Louis, to the northwest, where the channel, though silting up easily, offered an easier exit, a great advantage during the cyclone season or enemy attacks. The Dutch went on to develop a narrow strip of land on the eastern coastline. It was squeezed between the sea and the mountains, subject to bad weather, and during the rainy season, pounded by torrents of water washing away everything in its path. But it was here they found an abundance of ebony trees to fell and ship to Amsterdam. The Dutch exploited the ebony forests, building a road between Flacq and Grande-Rivière in the southeast in order to transport their harvest. They just as quickly cultivated the land they deforested. As a result, today sugar cane has completely replaced not only ebony but other native species around Flacq.

There are beautiful beaches in the East: Blue Bay and Chaland to the south, Trou-d'Eau-Douce, Palmar, Belle-Mare, Poste-Lafayette, and above all, Deer Island, just offshore. The airport at Plaisance, welcoming a thousand visitors a day, is just a few hundred metres from the Mare-aux-Songes. It was here in 1865 that George Clark, a teacher, discovered bones proving the existence of the dodo bird.

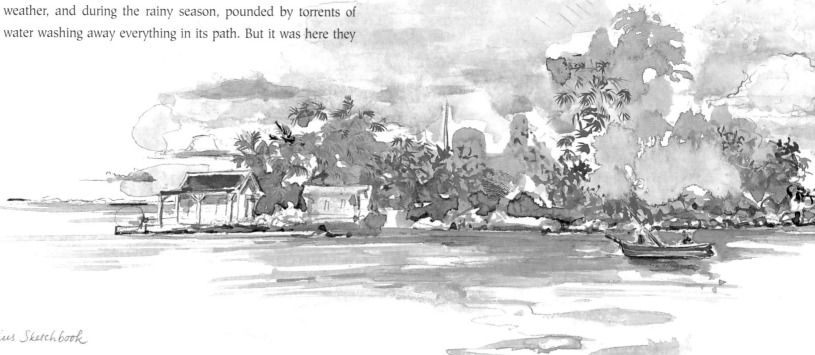

Even the most out-of-the-way village
has its own newspaper vendors, presiding
over a multitude of titles. These include
five daily papers, a weekly Chinese-language
paper, and a dozen different offerings on
Fridays and Sundays. Many browsers
cannot resist reading right at the shop,
but they usually end up buying something.

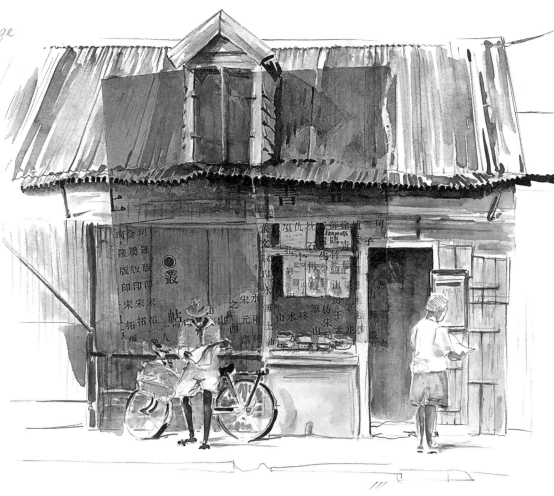

The Mouchoir Rouge (Red Handkerchief),
a tiny ruby island in Mahébourg's turquoise bay,
is typically Mauritian. Legend has it that
one must wave a red handkerchief to go to
the island or to leave it aboard a pirogue.

A Mahébourgian speciality:
building wooden ship models which
the purchasers sail with as much pride
as the owners of the originals. On display in the shop,
the suspended model boats seem to be competing in
their own regatta; and all the charm of the island is
contained in their carefully crafted hulls and
multicoloured sails.

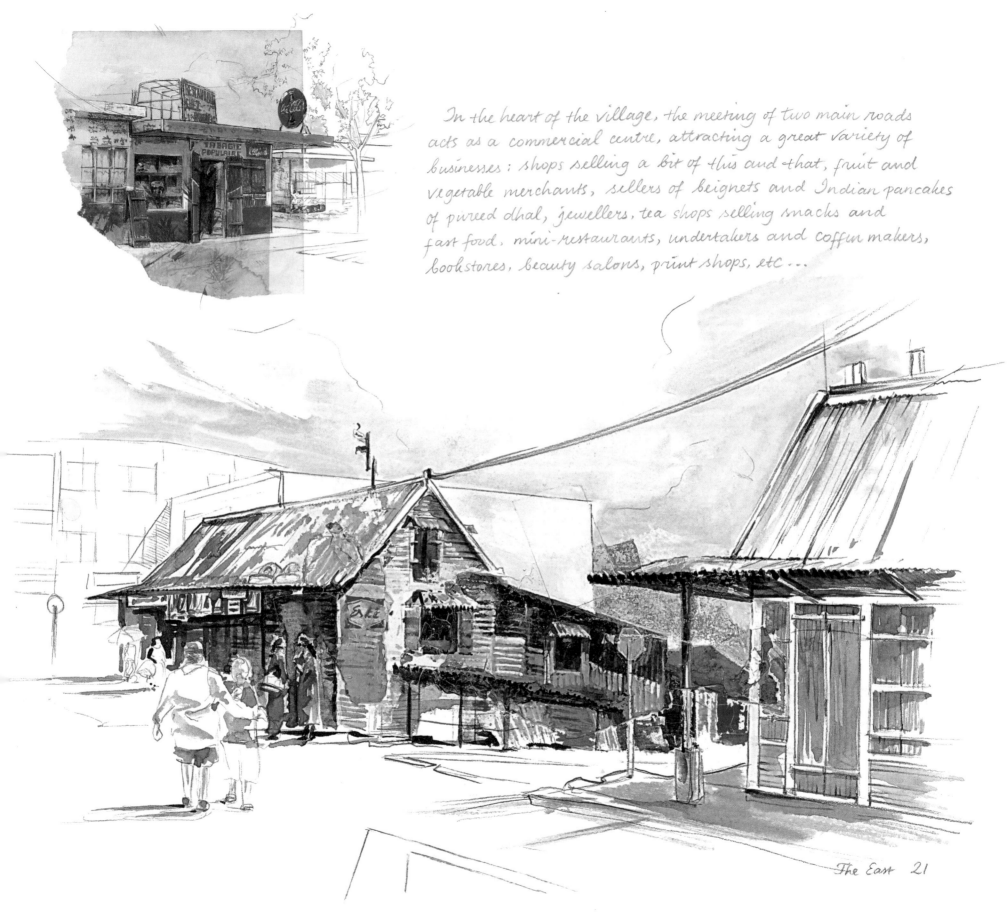

In the heart of the village, the meeting of two main roads acts as a commercial centre, attracting a great variety of businesses : shops selling a bit of this and that, fruit and vegetable merchants, sellers of beignets and Indian pancakes of pureed dhal, jewellers, tea shops selling snacks and fast food, mini-restaurants, undertakers and coffin makers, bookstores, beauty salons, print shops, etc ...

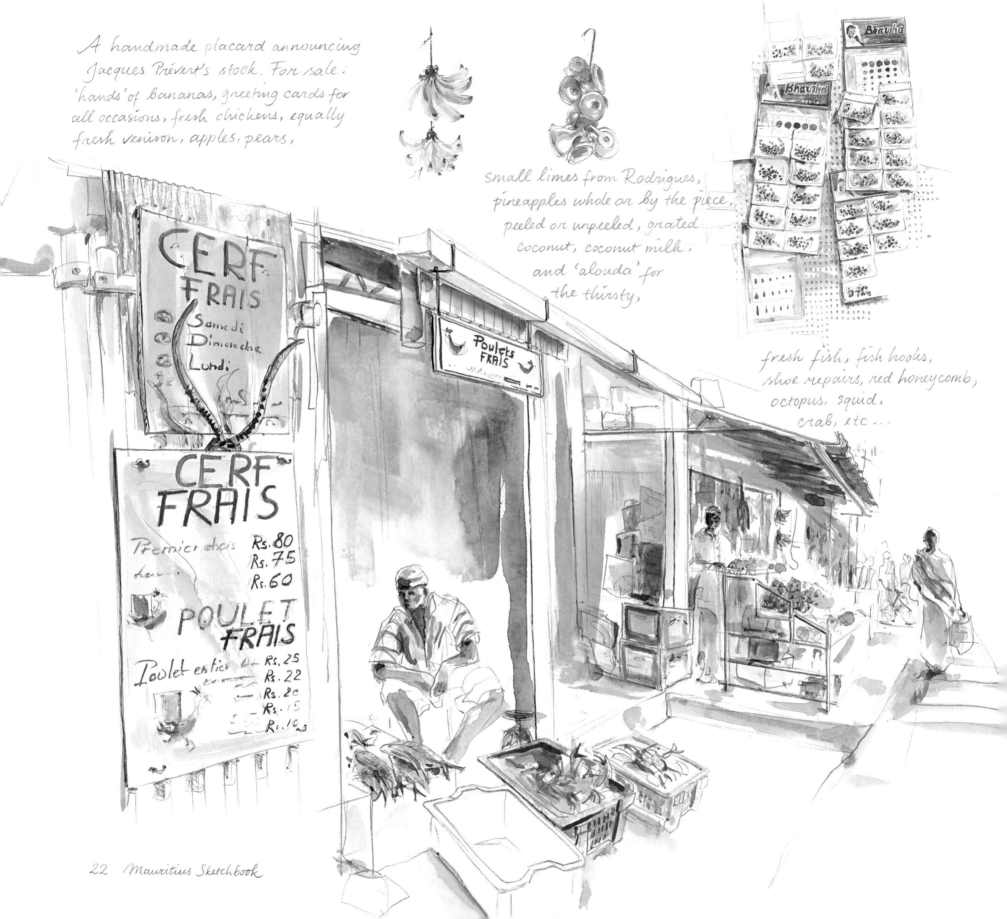

A handmade placard announcing Jacques Prévert's stock. For sale: 'hands' of bananas, greeting cards for all occasions, fresh chickens, equally fresh venison, apples, pears,

small limes from Rodrigues, pineapples whole or by the piece, peeled or unpeeled, grated coconut, coconut milk, and 'alouda' for the thirsty,

fresh fish, fish hooks, shoe repairs, red honeycomb, octopus, squid, crab, etc...

CERF FRAIS
Samedi
Dimanche
Lundi

CERF
FRAIS
Premier choix Rs. 80
 Rs. 75
ler... Rs. 60

POULET
FRAIS
Poulet entier Rs. 25
 Rs. 22
 Rs. 20
 Rs. 15
 Rs. 10

Poulets
FRAIS

Bhavika

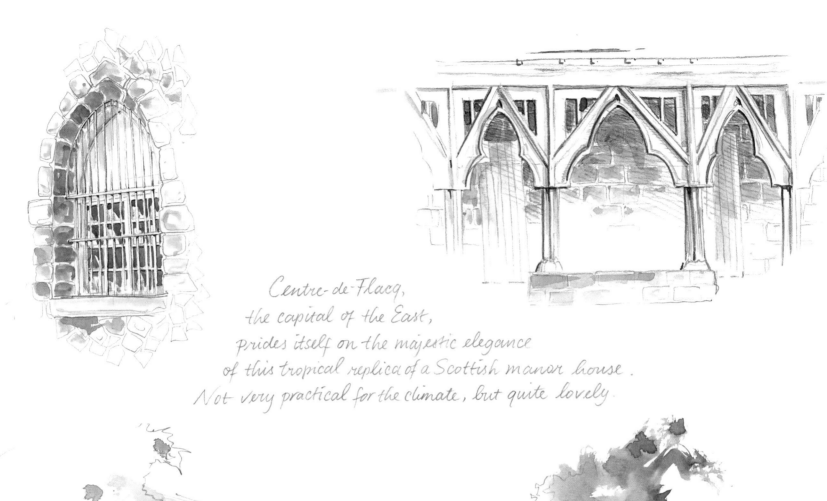

Centre-de-Flacq,
the capital of the East,
prides itself on the majestic elegance
of this tropical replica of a Scottish manor house.
Not very practical for the climate, but quite lovely.

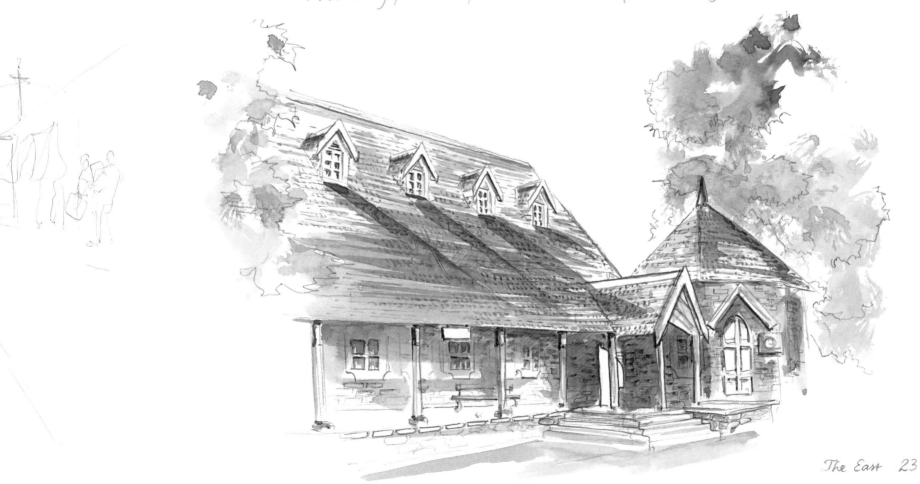

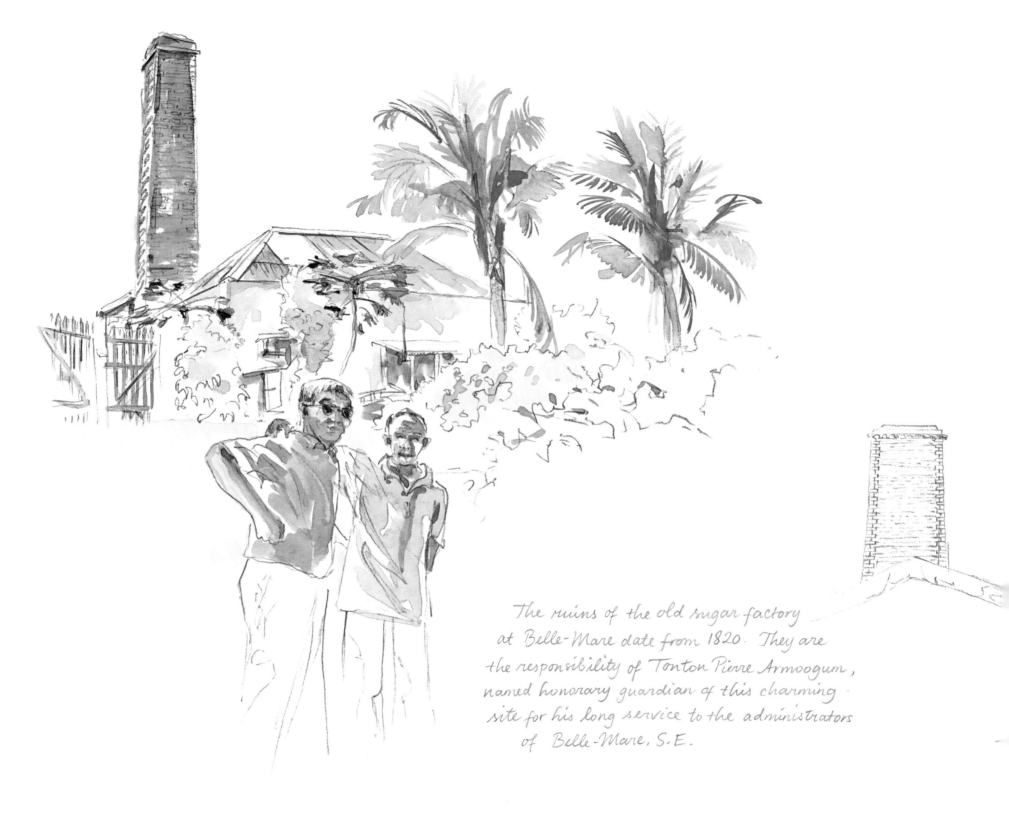

The ruins of the old sugar factory
at Belle-Mare date from 1820. They are
the responsibility of Tonton Pierre Armoogum,
named honorary guardian of this charming
site for his long service to the administrators
of Belle-Mare, S.E.

The crumbling walls poignantly illustrate the period of Mauritius' history when it boasted as many as 260 active sugar factories. Their story lives on in the magnificent chimneys, which have remained standing through more than a century of cyclones and droughts, and the unpredictability of the Mauritian sugar industry, whose success was dependent on the price of sugar in the world market. It was here at Belle-Mare that the first steam mill for grinding sugar cane was built in 1840.

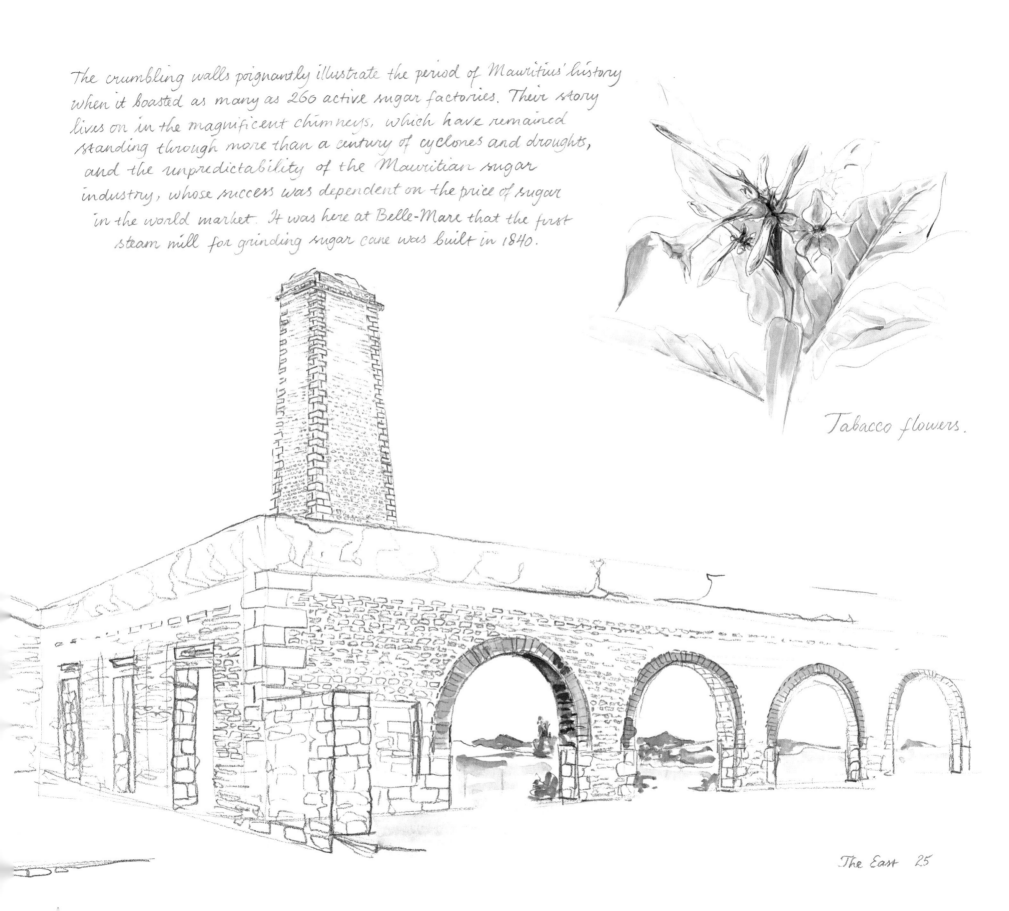

Tabacco flowers.

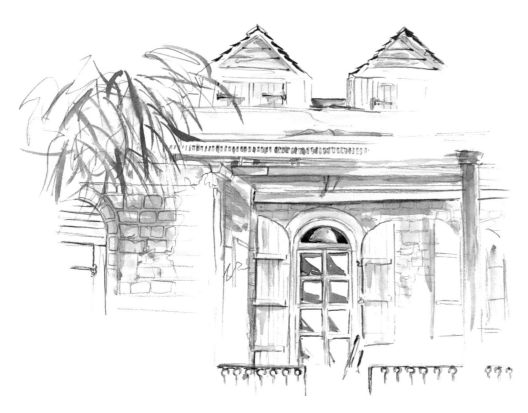

A little way off the coastal road
this old military post probably dates
from the French period. Today it is
the home of one of the settlement's
distinguished Muslim families.

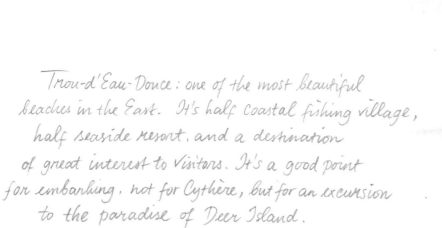

Trou-d'Eau-Douce: one of the most beautiful
beaches in the East. It's half coastal fishing village,
half seaside resort, and a destination
of great interest to visitors. It's a good point
for embarking, not for Cythère, but for an excursion
to the paradise of Deer Island.

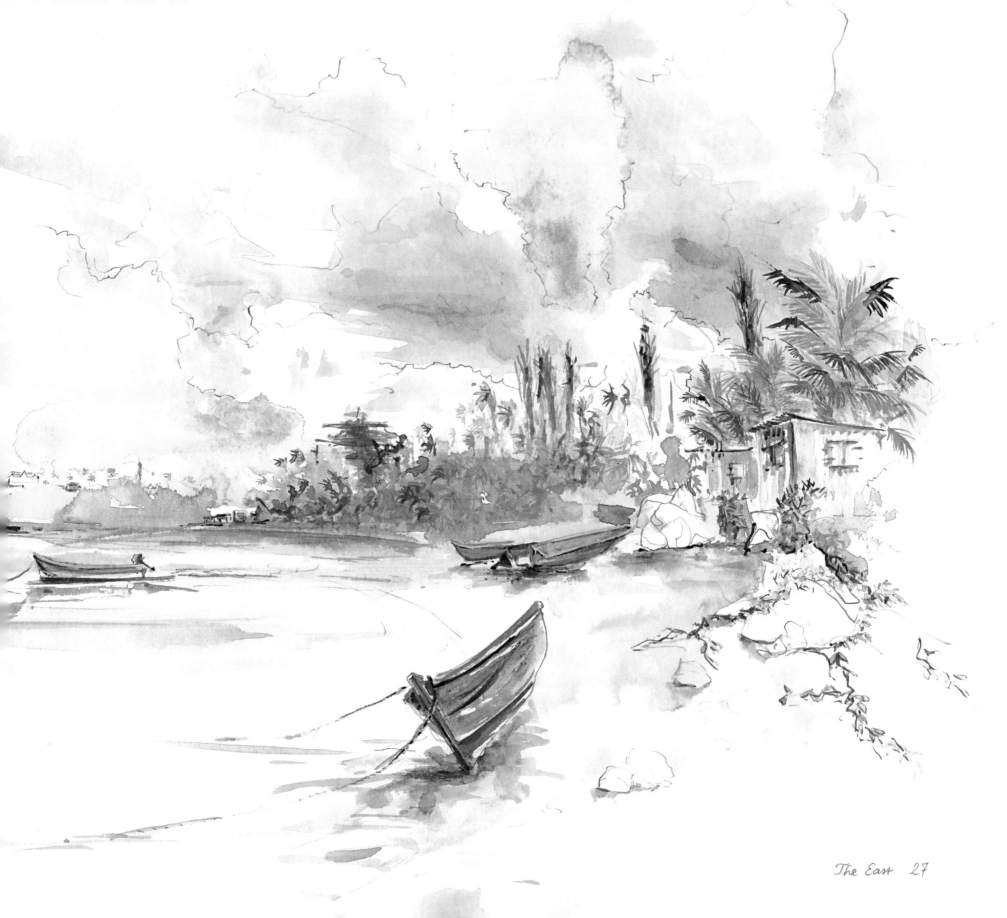

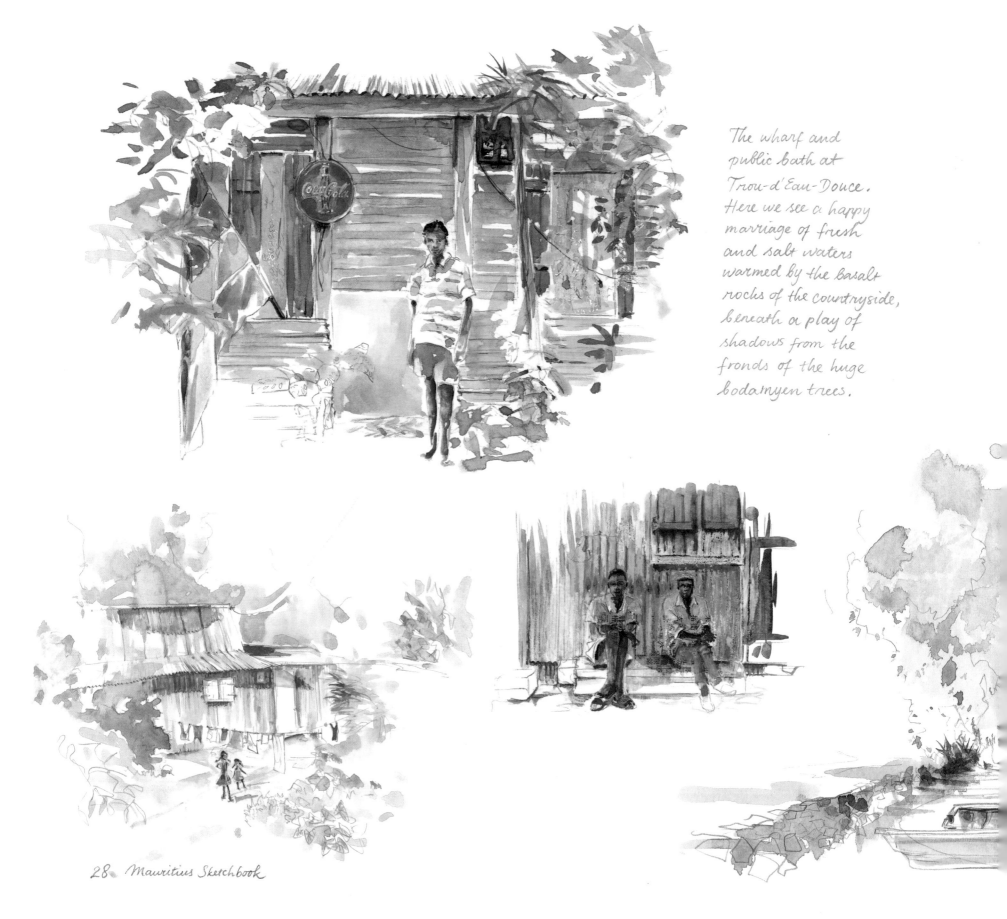

The wharf and
public bath at
Trou-d'Eau-Douce.
Here we see a happy
marriage of fresh
and salt waters
warmed by the basalt
rocks of the countryside,
beneath a play of
shadows from the
fronds of the huge
bodamyen trees.

28 Mauritius Sketchbook

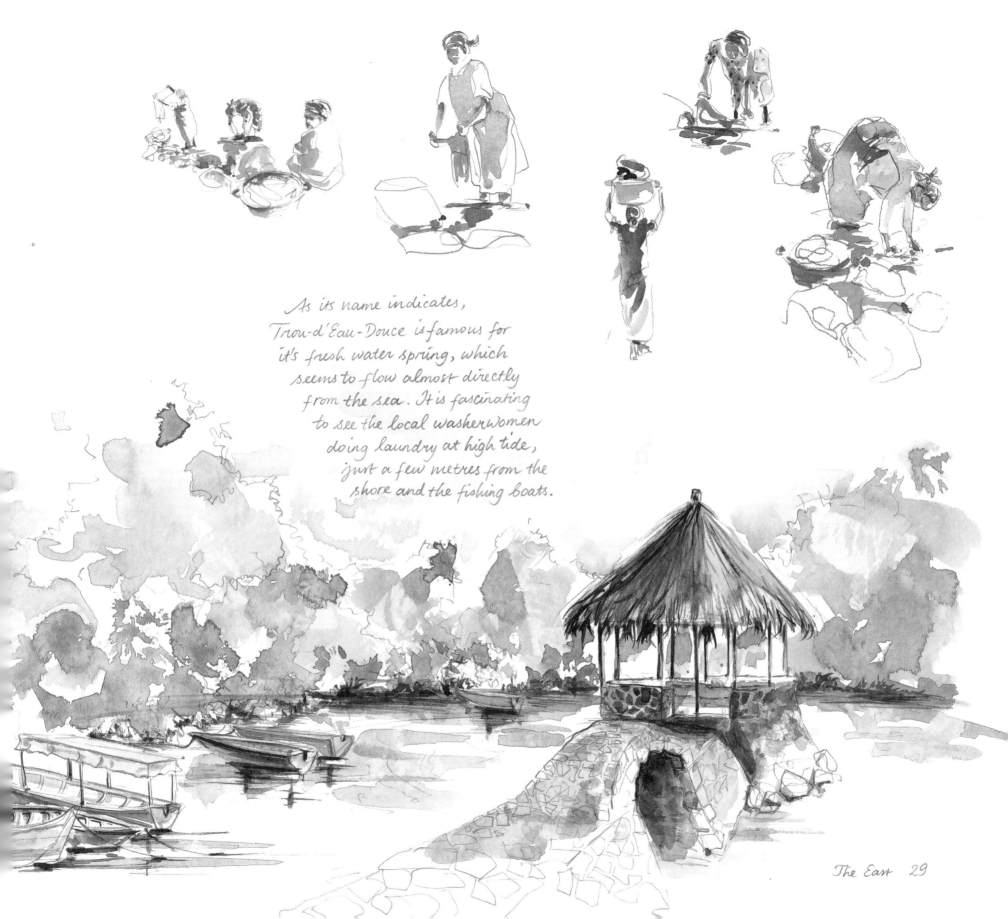

As its name indicates,
Trou-d'Eau-Douce is famous for
it's fresh water spring, which
seems to flow almost directly
from the sea. It is fascinating
to see the local washerwomen
doing laundry at high tide,
just a few metres from the
shore and the fishing boats.

Port-Louis

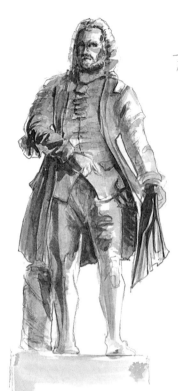

François Bertrand Mahé de La Bourdonnais (1699-1753), Governor of Isle de France (Mauritius) and Isle Bourbon (la Réunion) from 1735 to 1747, victor of the naval battle of Madras in September 1746, and the 'true' founder of the colony of Mauritius. A bronze copy of the statue was donated by Mauritius to his birthplace, Saint-Malo, France.

Port-Louis became the capital of Mauritius during the rule of Governor Nicolas de Maupin (1729-1735). La Bourdonnais had already transformed what had been an agglomeration of leaf-covered huts into a pretty little city with a promising future. Port-Louis has survived periods of great uncertainty about its future. Devastating cyclones, fires that repeatedly destroyed much of the city, epidemics of all kinds, floods, and economic depressions have all done their bit in testing Port-Louis' fortitude. But none of these events has ever truly tamed the entrepreneurial spirit of those who lived there.

From the time of the French colonization, Port-Louis enjoyed its status as the capital city, while the rest of the island was either rural, or worse, developed into *habitations* (large agricultural estates) – these days, a *zens(e)bitation* (someone belonging to an estate) remains Mauritian slang for a dolt. The capital was a magnet which drew people living in the countryside to see its splendours. They would travel to Port-Louis and return to their villages as great adventurers, filled with stories of the big city. Decades of seasonal malaria epidemics began in about 1867, during which time Port-Louis lost a bit of its spirit. Wealthy citizens migrated to the safety of the highlands, but returned to Port-Louis during the winters, revitalizing the city. There they would frolic at the Governor's Ball, enjoy the theatre and musical season, race days at the Turf Club, regattas in the harbour, bazaars, Saint-Louis celebrations, horticultural and crafts fairs in the central market, concerts, and, much later, epic soccer matches.

Port-Louis experienced a period of decline following World War Two. Younger cities began to compete with it. The seaside and its attractions gained prominence as inviting places for socializing and relaxing, and seaside bungalows were favoured over beautiful Creole homes. But Port-Louis remained the nerve centre for business, as well as for other activities. It was in the capital that things essential for the country were decided and accomplished. Business headquarters were based there. More recently, Port-Louis has established itself as an economic free port. Air Mauritius, Mauritius Telecom, banks, and twenty-story skyscrapers are all found here. Port-Louis has become a truly modern city. The seashores of Caudan and Port-Louis complete our picture of the capital. These lively playgrounds for visitors and Mauritians alike enhance the city's attractiveness. Three centuries after La Bourdonnais' miracle, Port-Louis still looks forward, facing the twenty-first century as the enduring and dignified capital of Mauritius and its million inhabitants.

The Poncini store in front of the Port-Louis municipal theatre, descendant of the earlier Guillemin shop. Inside can be found a century of venerable commercial tradition, as well as expertise in the jewel trade, jewellery making, and clock making.

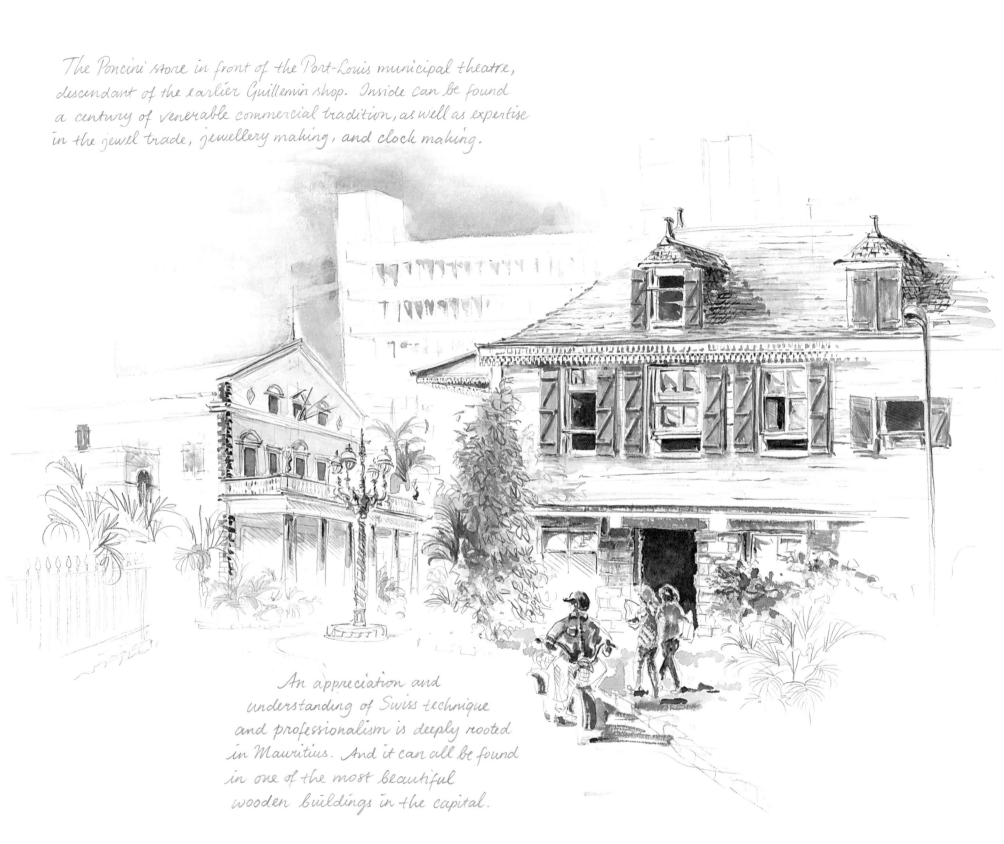

An appreciation and understanding of Swiss technique and professionalism is deeply rooted in Mauritius. And it can all be found in one of the most beautiful wooden buildings in the capital.

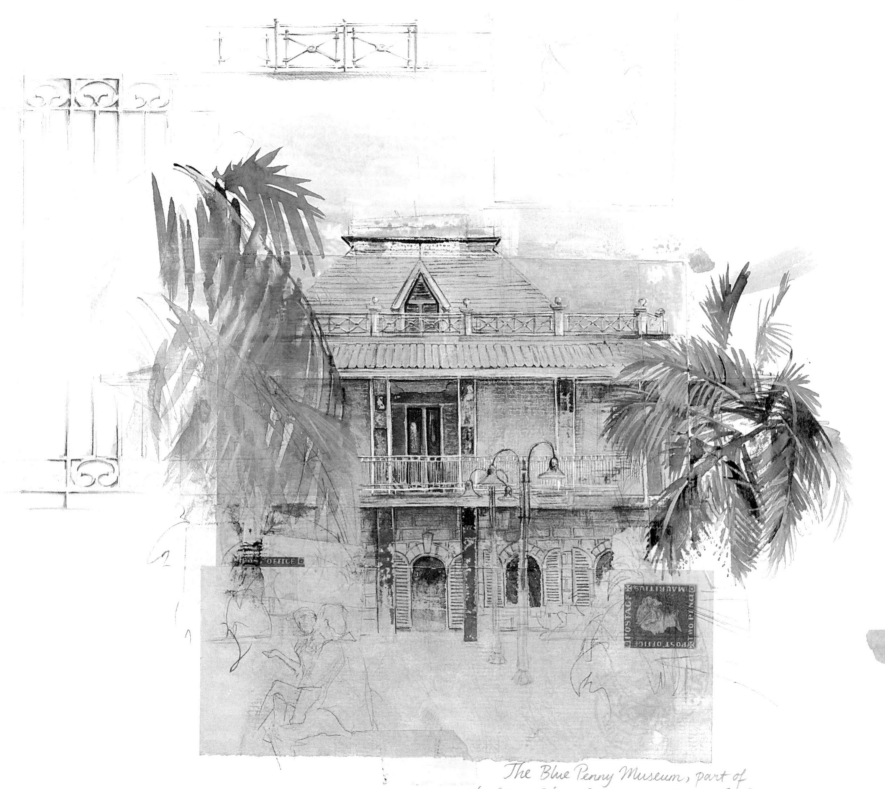

The Blue Penny Museum, part of
the Mauritius Commercial Bank Limited.
The bank was started in 1838, and has invested
heavily in purchasing works of art.

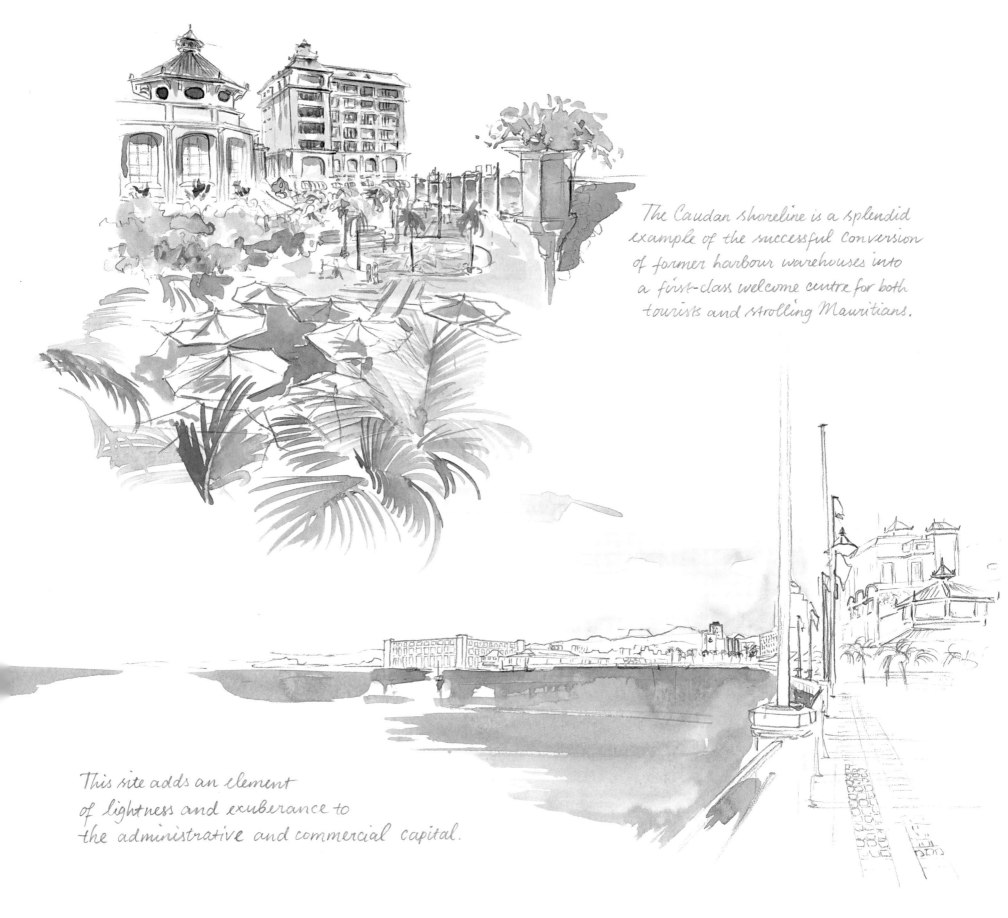

The Caudan shoreline is a splendid example of the successful conversion of former harbour warehouses into a first-class welcome centre for both tourists and strolling Mauritians.

This site adds an element of lightness and exuberance to the administrative and commercial capital.

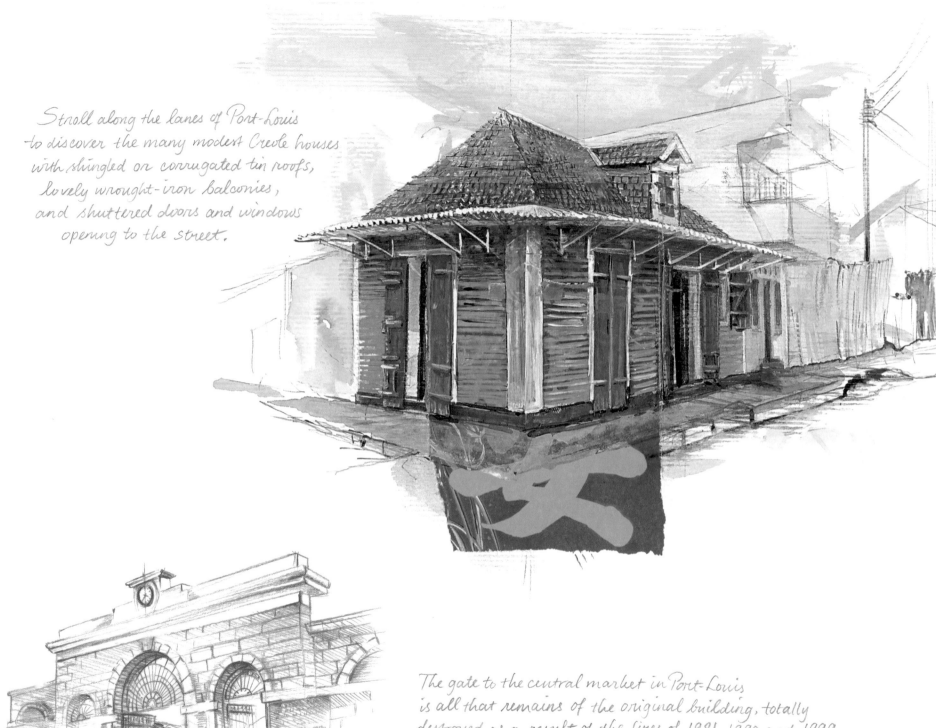

Stroll along the lanes of Port-Louis
to discover the many modest Creole houses
with shingled or corrugated tin roofs,
lovely wrought-iron balconies,
and shuttered doors and windows
opening to the street.

The gate to the central market in Port-Louis
is all that remains of the original building, totally
destroyed as a result of the fires of 1981, 1990 and 1999.

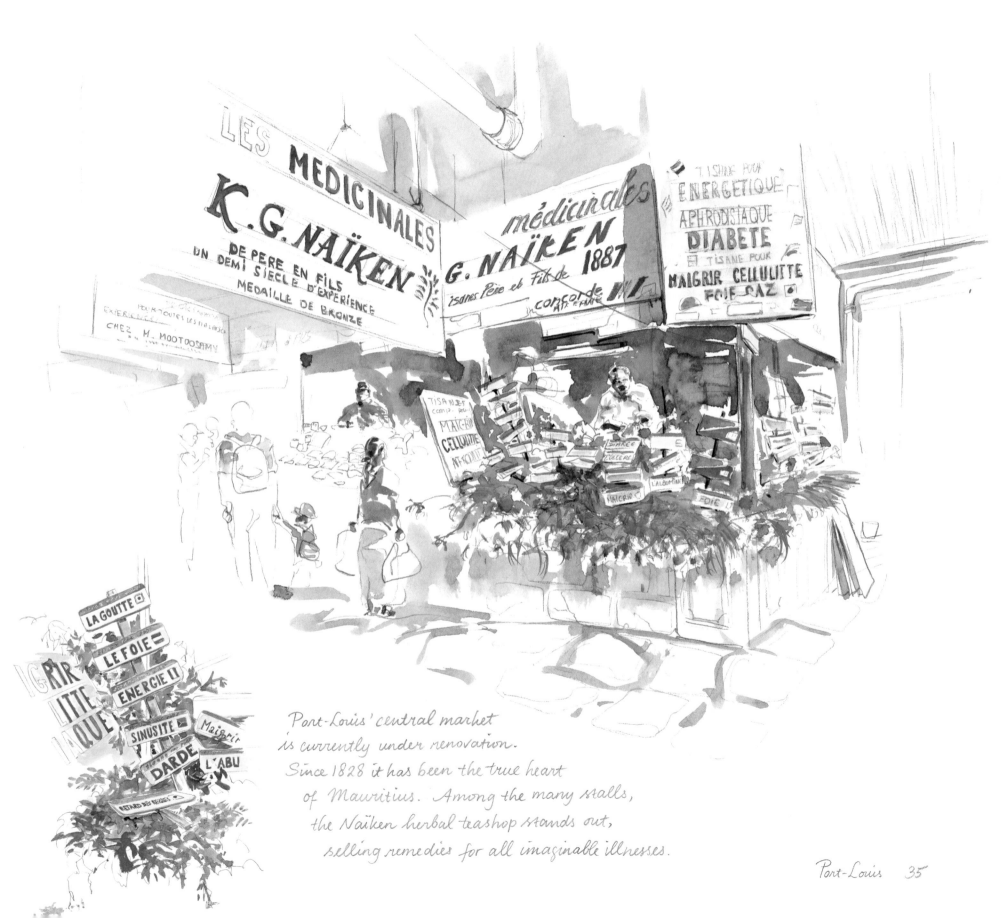

Port-Louis' central market
is currently under renovation.
Since 1828 it has been the true heart
 of Mauritius. Among the many stalls,
 the Naïken herbal teashop stands out,
 selling remedies for all imaginable illnesses.

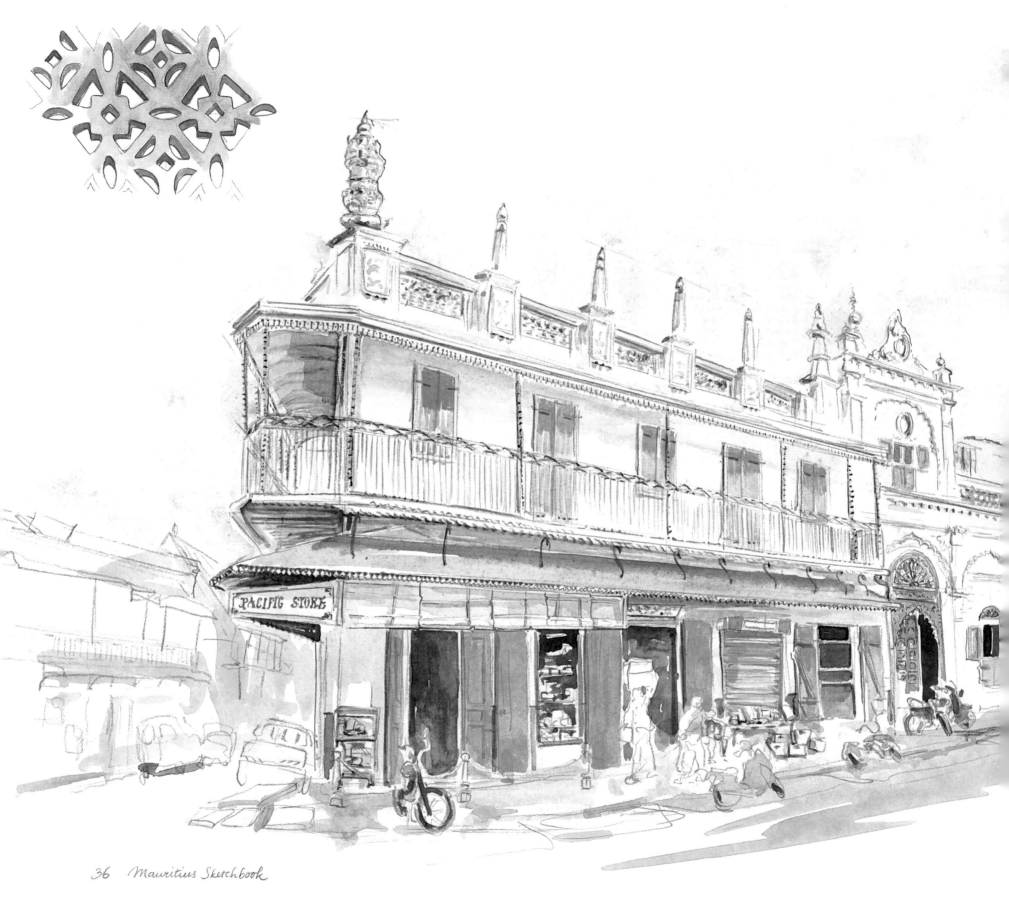

PACIFIC STORE

The Jummah Mosque, one of the most beautiful religious edifices in Mauritius. Its contours, decoration, and endless, meticulous upkeep are a work of devotion. Only its congregation's infinite love for God can explain this architectural marvel. The mosque was born through the initiative of Muslim businessmen in the mid-seventeenth century, who were unable to leave their stores in the city centre to go and pray at distant Al-Aqsa, in Plaine-Verte, the only mosque on the island at the time. In 1852 they decided to build the Jummah Mosque right in the middle of their business district.

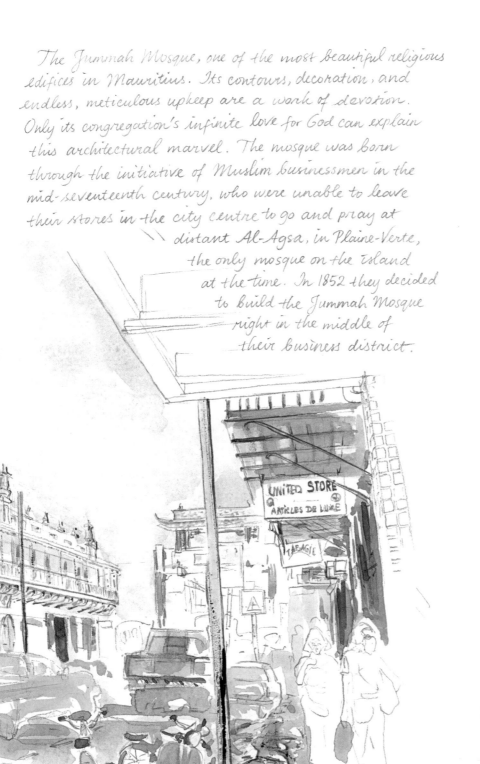

Wood, iron, and
cast-iron have remained
favourite materials for
Mauritian builders
and furniture craftsmen
since French colonization
in the eighteenth century.
Recent construction
of course involves newer
building styles and
materials such as
concrete and PVC.

A mandarin.

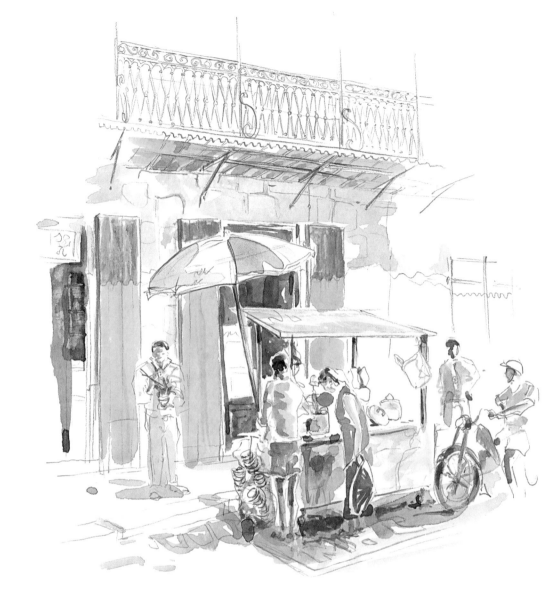

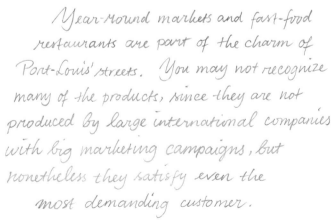

Year-round markets and fast-food restaurants are part of the charm of Port-Louis' streets. You may not recognize many of the products, since they are not produced by large international companies with big marketing campaigns, but nonetheless they satisfy even the most demanding customer.

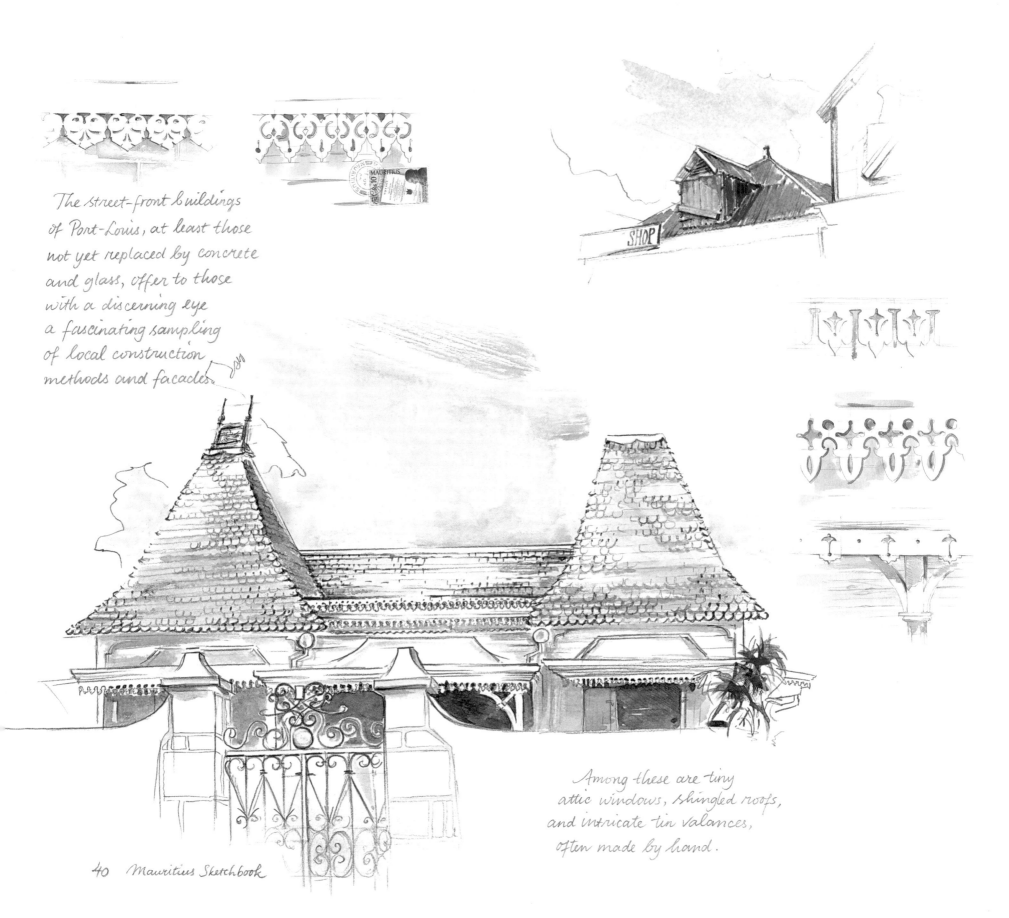

The street-front buildings of Port-Louis, at least those not yet replaced by concrete and glass, offer to those with a discerning eye a fascinating sampling of local construction methods and facades.

Among these are tiny attic windows, shingled roofs, and intricate tin valances, often made by hand.

Since 1868, this building at the place du Quai
has served as the general headquarters
for the Mauritians postal service. It is
one of the oldest post offices in the world.
The current plan to move it elsewhere,
to make room for the African Cultural Centre,
is a strange fate for this venerable old building.

As in the past,
the floor above the store
serves as the merchant
family's home, and
occasionally even for some
employees. More and more
frequently though, especially
in the city centre, such spaces
are being converted into offices.

The Kouan-Ti Pagoda at Salines is the most important place of worship for Mauritian Buddhists. It was built by Hachime Choisanne and inaugurated on 7 February 1842. Its congregation follows religious practices dictated by the then reigning Chinese emperor. The Kouan-Ti Pagoda was given special protected status and is held in trust for Mauritians of Chinese descent. In 1821, Choissane was given permission to assist immigrants from the Chinese province of Fukien, whom he had to guarantee financially. After 1860, though, Fukien Chinese immigrants were outnumbered by Hakka Chinese from Canton province.

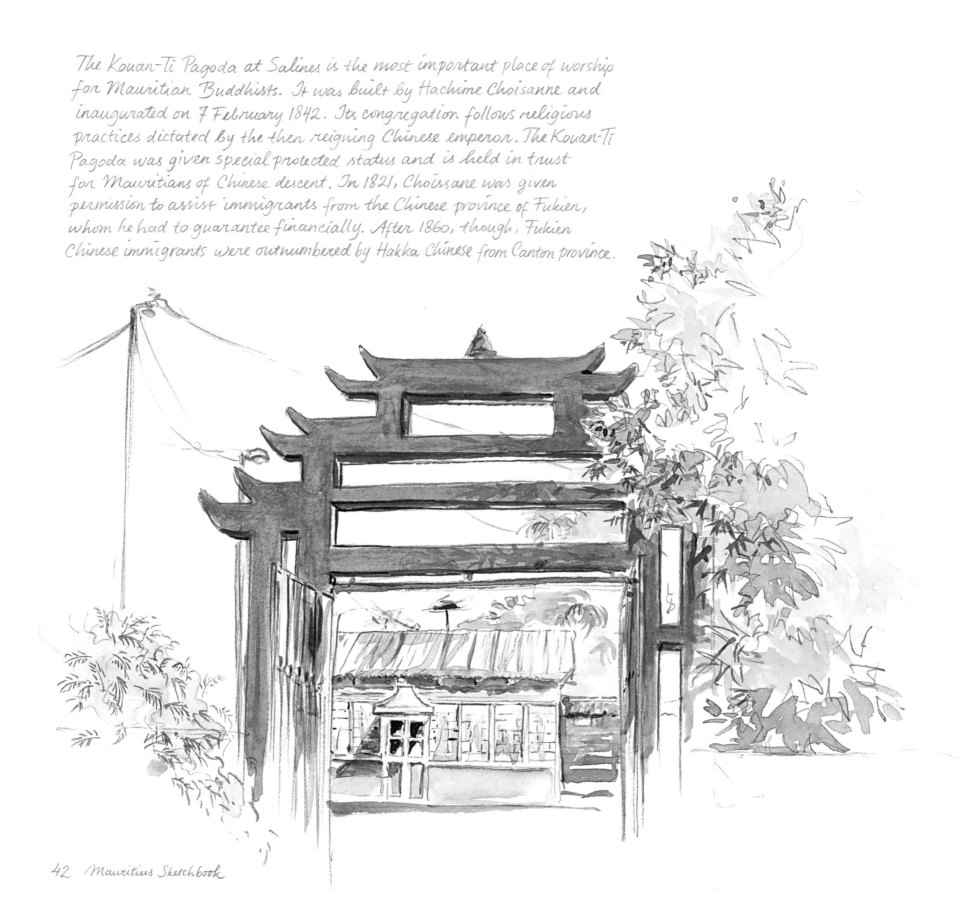

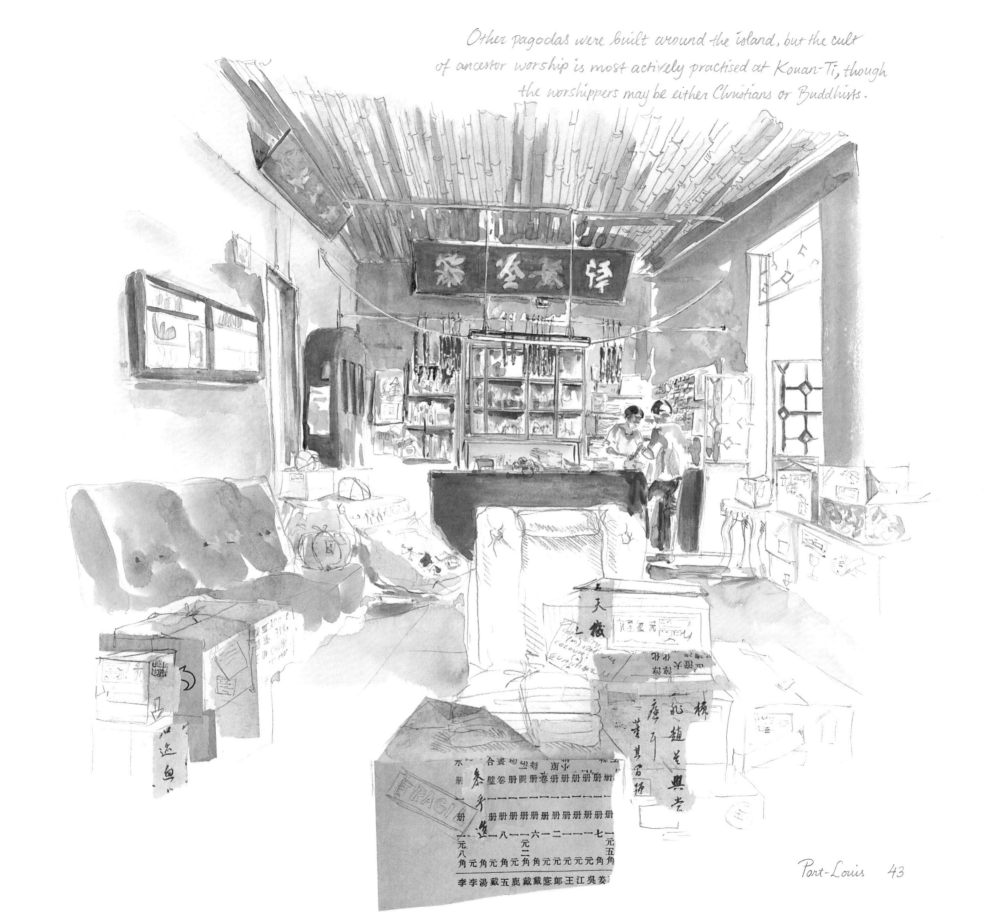

Other pagodas were built around the island, but the cult of ancestor worship is most actively practised at Kouan-Ti, though the worshippers may be either Christians or Buddhists.

The North

It's easy to reach the adjacent district of the North from Port-Louis. Viewed from the sea, the landscape is flatter and more hospitable than the deeply shaded highlands. The first Dutch to arrive explored the nearby bays of Tombeau, Tortues (today known as Arsenal and Balaclava), and Grande-Rivière-Nord-Ouest. The French who followed ventured as far as Calebasses, Pamplemousses, Montagne-Longue, and later even further, Poudre d'Or and Rivière-du-Rempart. They built military outposts at Poste-Lafayette and Poste-de-Flacq. As their northerly exploration shifted east and south, they would met the Dutch at Grand-Port.

The French, encouraged by Mahé de La Bourdonnais, wanted to transform the island into a storehouse for ships on the Asia sea route. They offered commercial concessions to arriving colonists, who were then responsible for replenishing the holds of arriving ships, as well as military garrisons. The Europeans were not used to working outside under the tropical sun. They also discovered that Mauritius' volcanic soil was much too rocky to be worked with the same ploughs they had used in Europe. Eventually the colonists were forced to bring slaves from Africa and Madagascar to prepare the fields by hand. The tropical climate forced farmers to abandon the crops they had planted in the temperate zones of Europe, and turn instead to spices (nutmeg, cloves and pepper), and later to sugar-cane. Steam-driven sugar mills replaced those that had been powered by wind, water and animals. From that crucial moment on, nothing would stand in the way of the sugar industry's progress, and today, sugar is the mainstay of the Mauritian economy.

Be sure not to leave the North without a visit to the Pamplemousses Botanic Garden, and The Sugar Adventure, the former Beau-Plan sugar factory, now an important museum dedicated to the history of sugar in Mauritius. They provide a stimulating and rewarding introduction to Mauritius' agricultural and sugar-manufacturing history.

The chapel at Cap-Malheureux, dedicated to Notre-Dame Auxiliatrice, is situated in one of Mauritius' most beautiful landscapes. Tiny Coin-de-Mire island is visible on the horizon. General Abercrombie and his English sailors disembarked here in November 1810, successfully seizing Mauritius. Here, far from the protection of Napoleon's France, the British hoped to reinforce their strategic position in the vast oceans of the East.

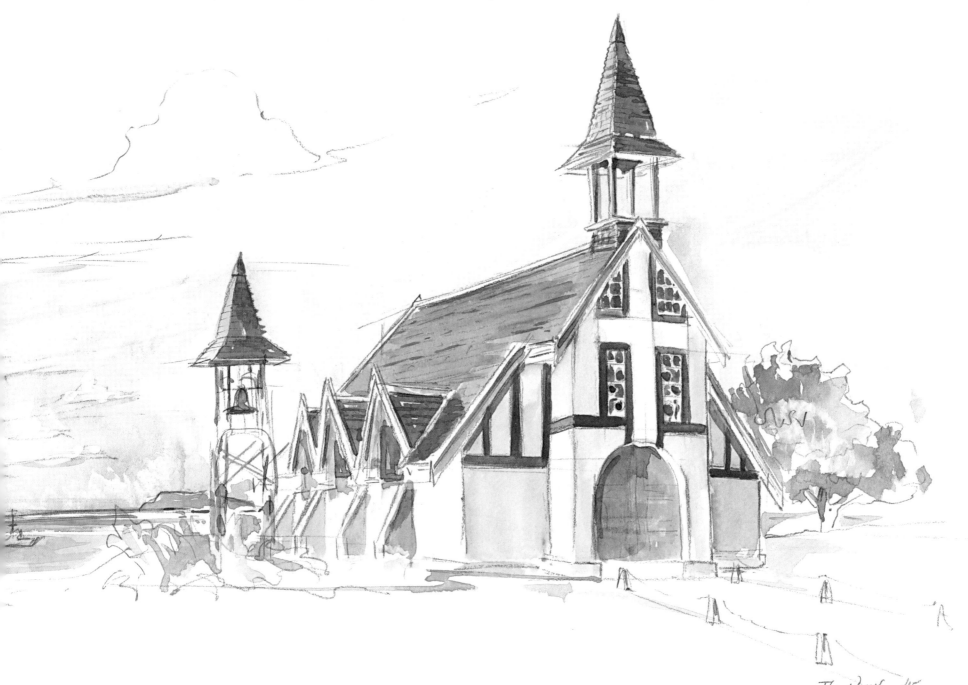

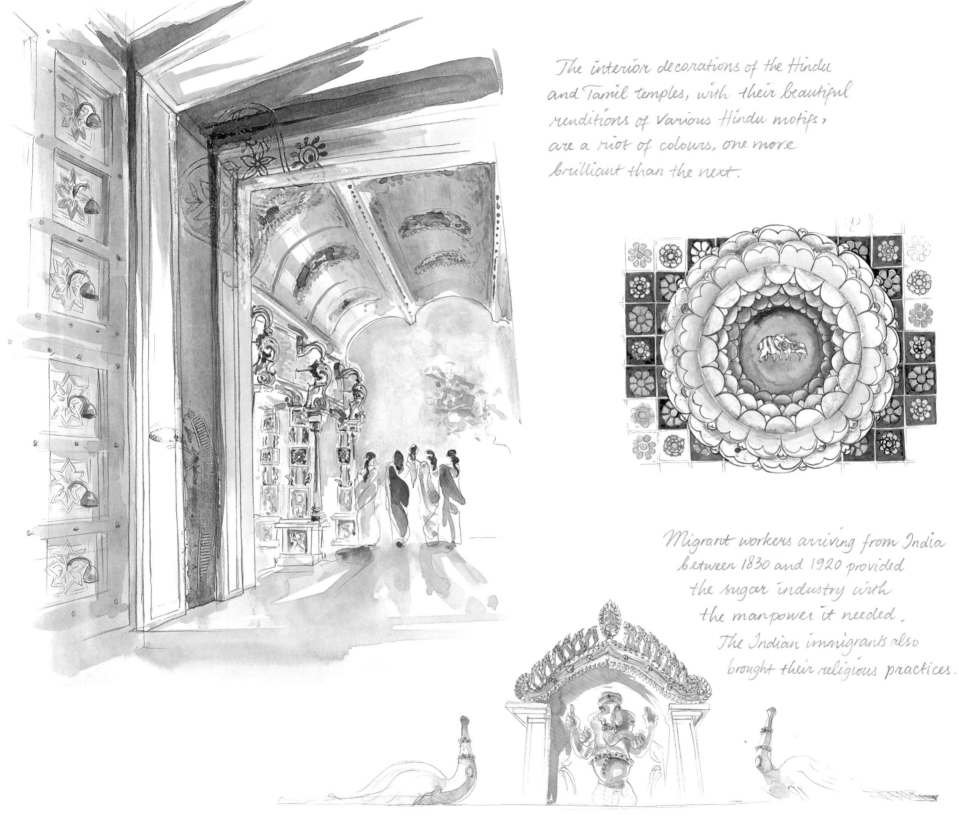

The interior decorations of the Hindu
and Tamil temples, with their beautiful
renditions of various Hindu motifs,
are a riot of colours, one more
brilliant than the next.

Migrant workers arriving from India
between 1830 and 1920 provided
the sugar industry with
the manpower it needed.
The Indian immigrants also
brought their religious practices.

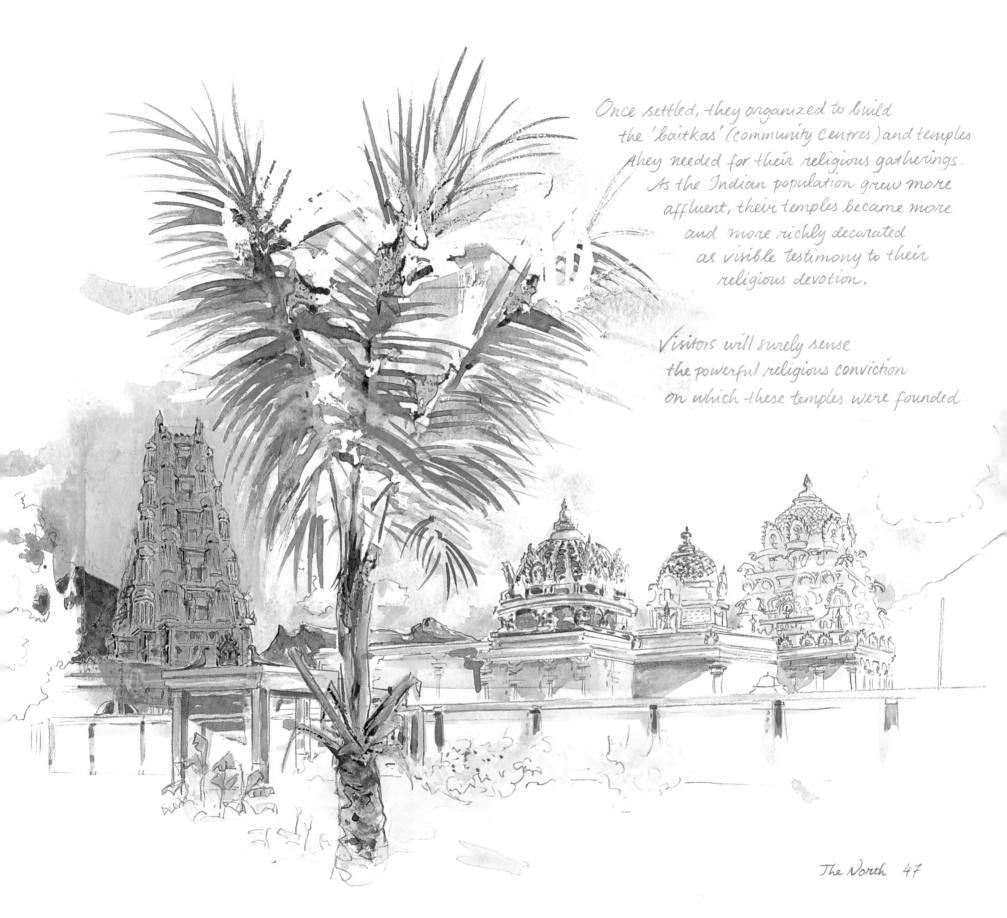

Once settled, they organized to build
the 'baitkas' (community centres) and temples
they needed for their religious gatherings.
As the Indian population grew more
affluent, their temples became more
and more richly decorated
as visible testimony to their
religious devotion.

Visitors will surely sense
the powerful religious conviction
on which these temples were founded.

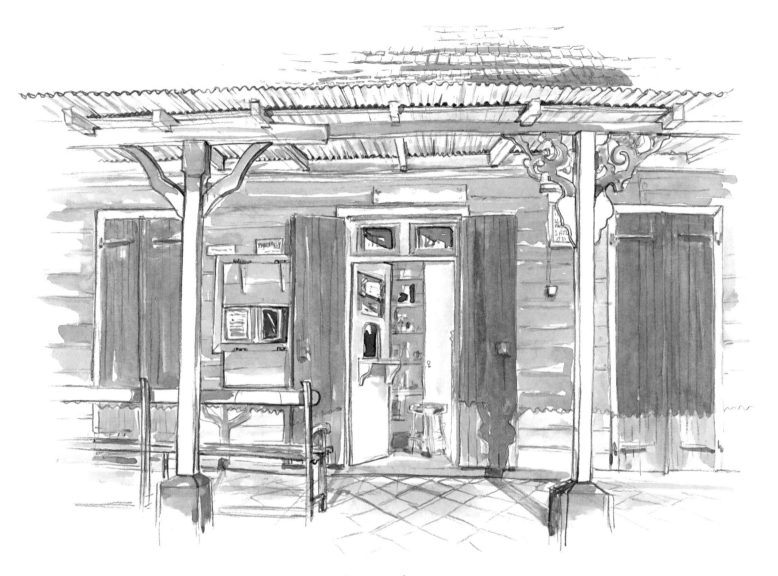

The hospital at Montagne-Longue is a delightful example
of nineteenth-century English colonial architecture. A curious
mélange of British and Mauritian know-how, it was built with
techniques normally suited to European construction materials,
but here successfully adapted to the needs of
Mauritius' tropical climate.

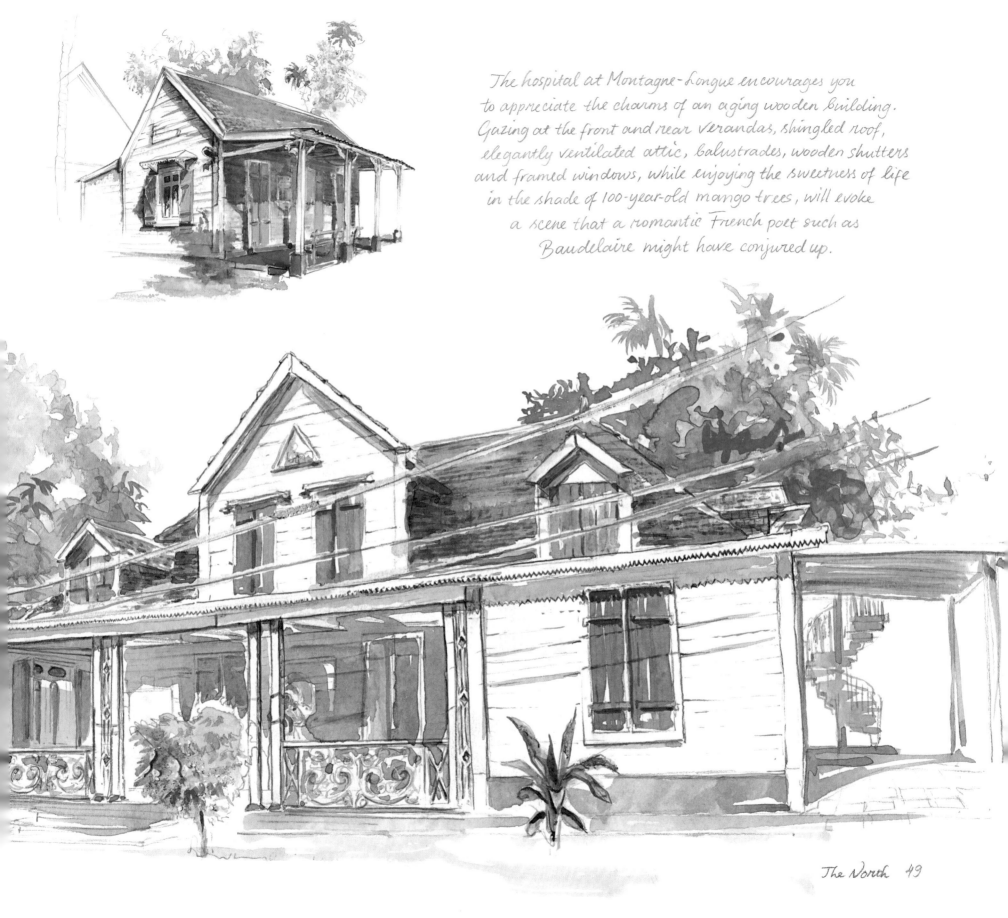

The hospital at Montagne-Longue encourages you
to appreciate the charms of an aging wooden building.
Gazing at the front and rear verandas, shingled roof,
elegantly ventilated attic, balustrades, wooden shutters
and framed windows, while enjoying the sweetness of life
in the shade of 100-year-old mango trees, will evoke
a scene that a romantic French poet such as
Baudelaire might have conjured up.

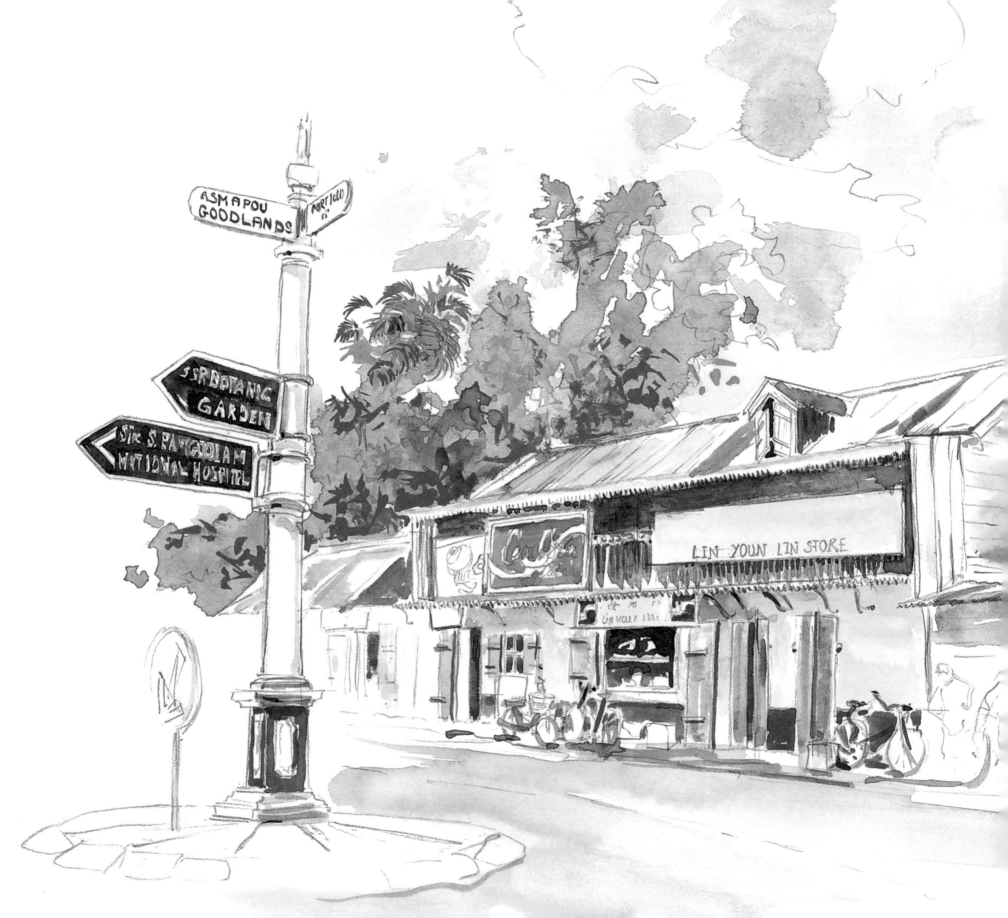

Sir William Stevenson (1805-1863) was governor
of Mauritius from 1857 to 1863. Mauritians are indebted to him
for his many major improvements to both the administration
and the infrastructure of the country, including the construction
of the railway, the doubling in number of the public schools,
and the social and economic progress of Indian immigrants.

Partly because of his early
initiatives, this Indian villager,
with her air of pride
and determination, knows
her family will thrive.

The Pamplemousses Quarter, where the roads
from Port-Louis, Flacq and the northern plains all meet.
The Lin Youn Lin store, a gentle reminder of the many Chinese
shopkeepers who migrated from China in the nineteenth century
to become an essential part of the Mauritian economy.

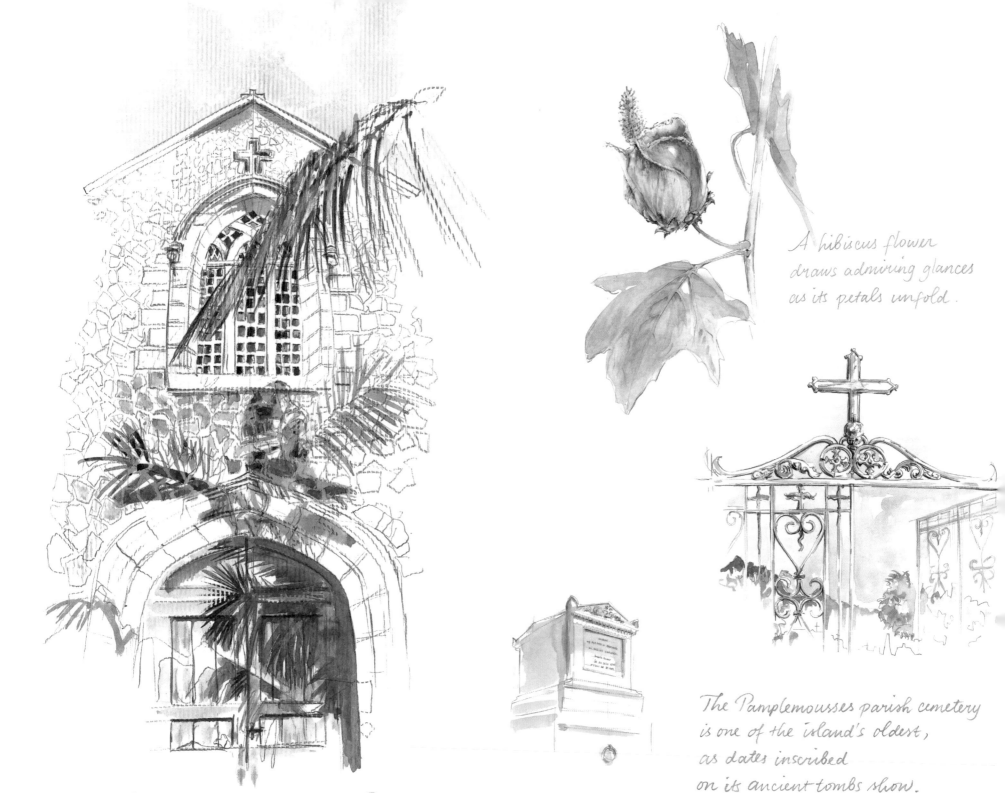

A hibiscus flower
draws admiring glances
as its petals unfold.

The Pamplemousses parish cemetery
is one of the island's oldest,
as dates inscribed
on its ancient tombs show.

The Saint-Barnabas anglican church, at Pamplemousses,
dating from 9 November 1859. The foundation stone was laid
on 11 June 1857, by Vincent William Ryan, the first bishop of Mauritius.

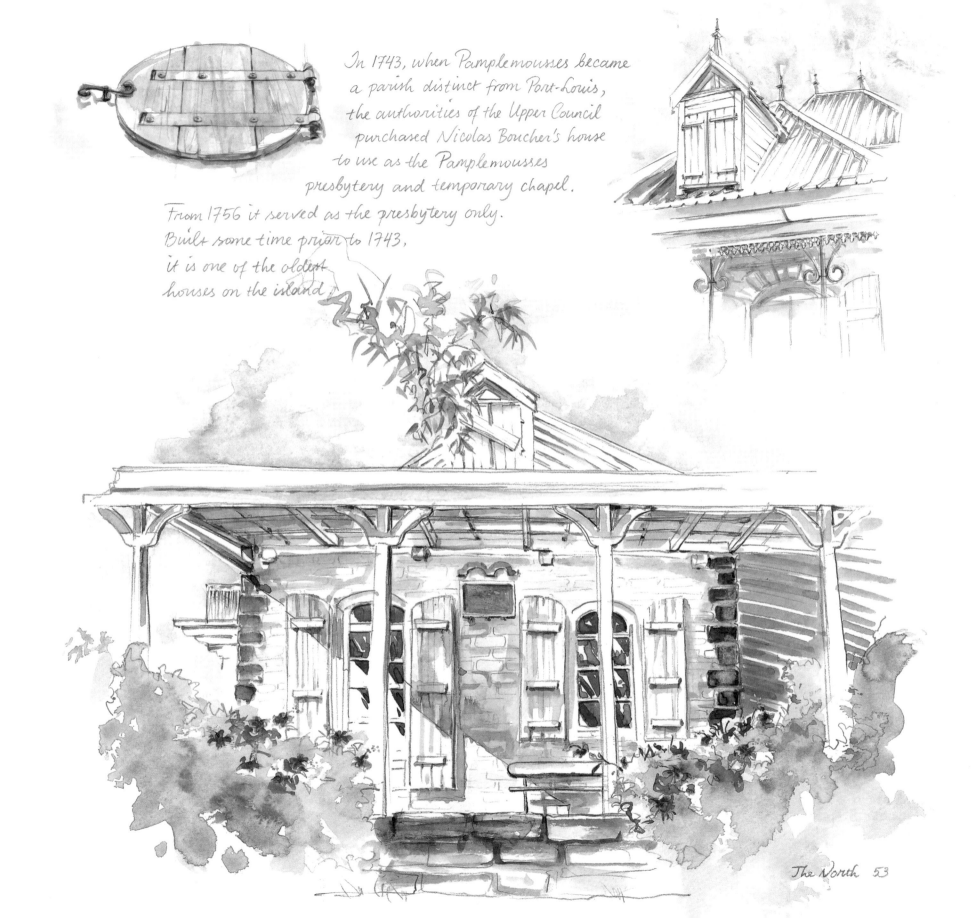

In 1743, when Pamplemousses became a parish distinct from Port-Louis, the authorities of the Upper Council purchased Nicolas Boucher's house to use as the Pamplemousses presbytery and temporary chapel. From 1756 it served as the presbytery only. Built some time prior to 1743, it is one of the oldest houses on the island.

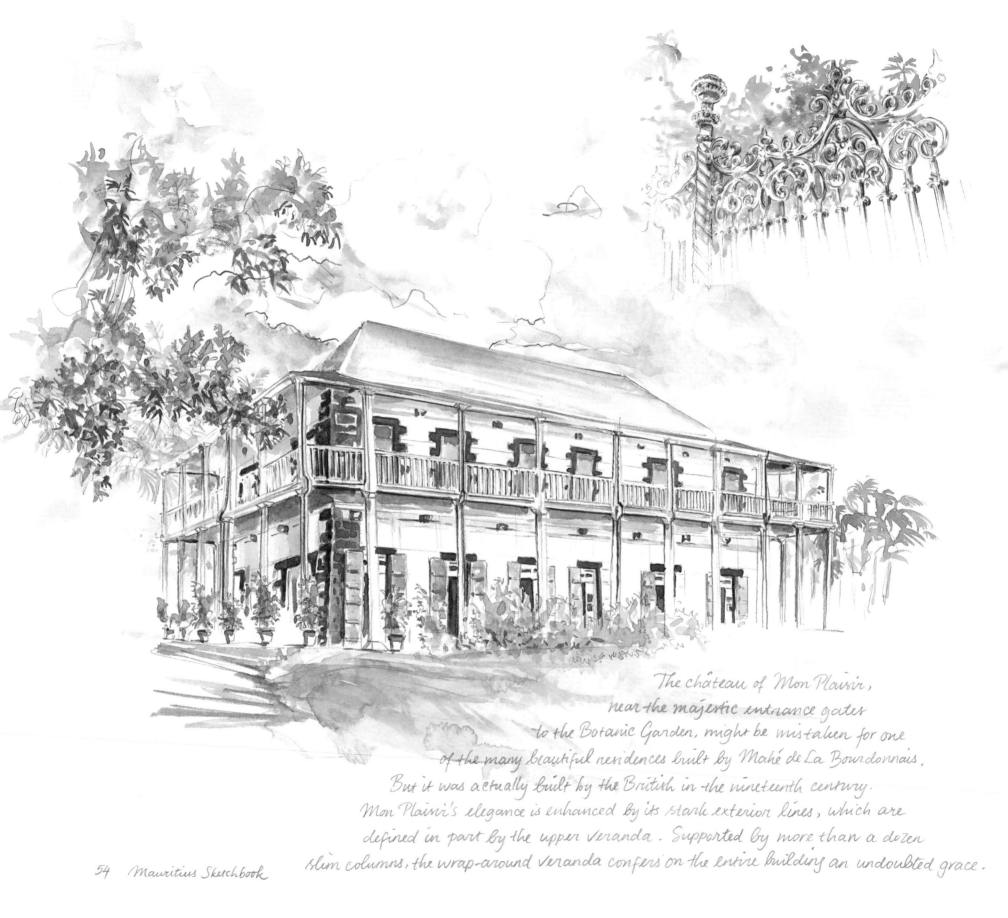

The château of Mon Plaisir,
near the majestic entrance gates
to the Botanic Garden, might be mistaken for one
of the many beautiful residences built by Mahé de La Bourdonnais.
But it was actually built by the British in the nineteenth century.
Mon Plaisir's elegance is enhanced by its stark exterior lines, which are
defined in part by the upper veranda. Supported by more than a dozen
slim columns, the wrap-around veranda confers on the entire building an undoubted grace.

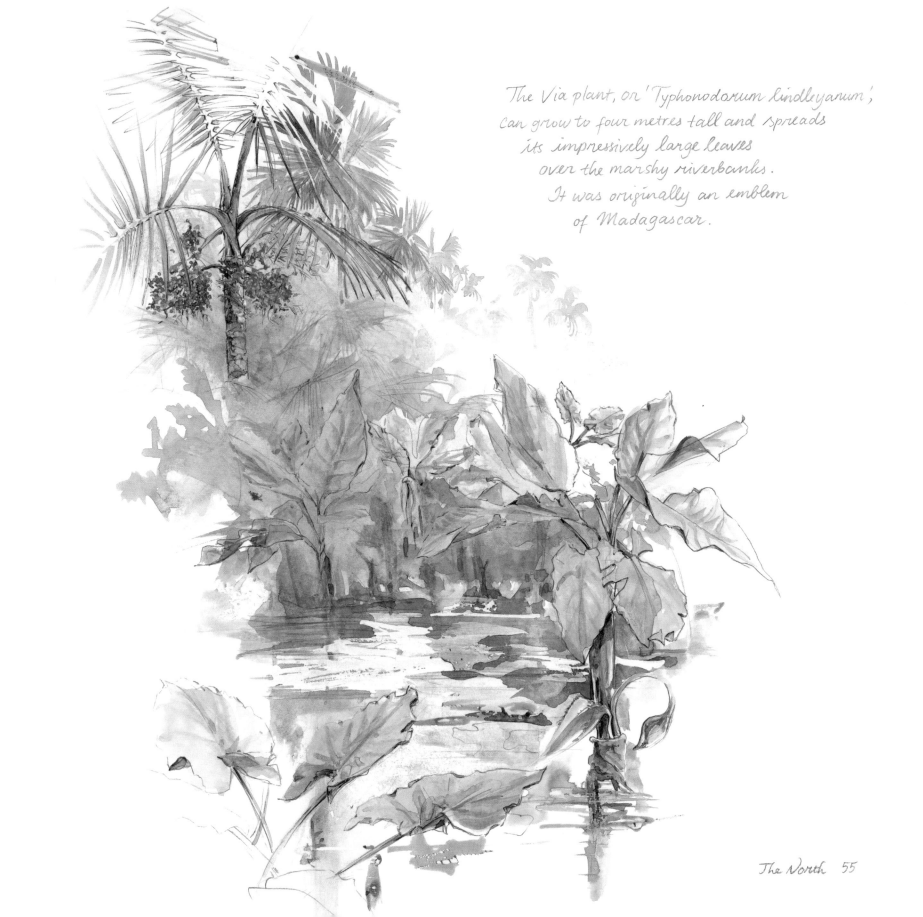

The Via plant, or 'Typhonodorum lindleyanum',
can grow to four metres tall and spreads
its impressively large leaves
over the marshy riverbanks.
It was originally an emblem
of Madagascar.

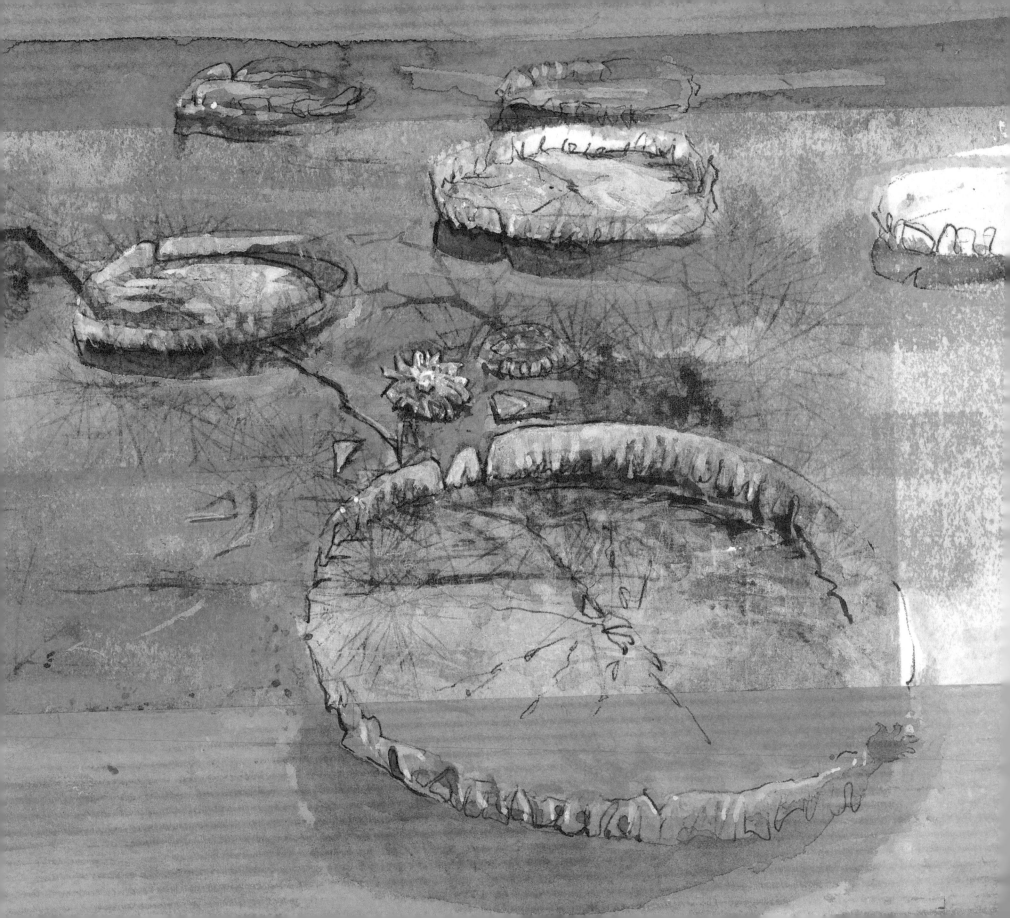

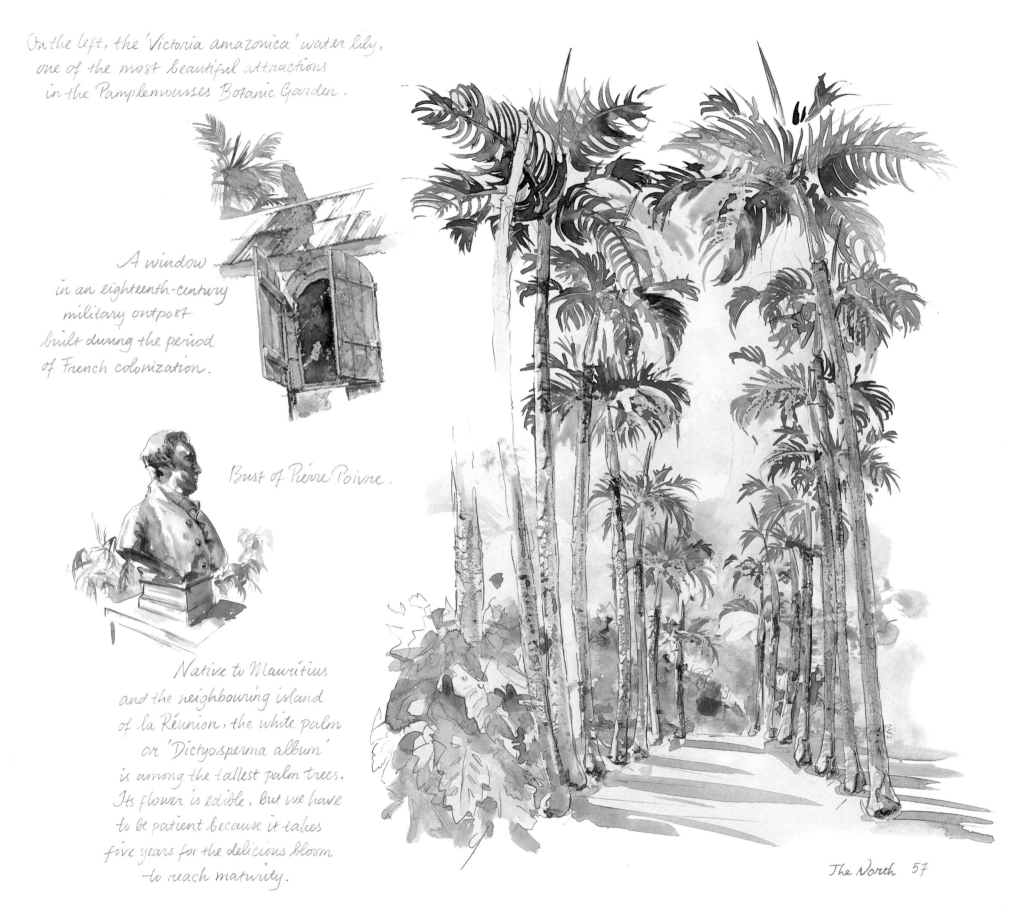

On the left, the 'Victoria amazonica' water lily, one of the most beautiful attractions in the Pamplemousses Botanic Garden.

A window in an eighteenth-century military outpost built during the period of French colonization.

Bust of Pierre Poivre.

Native to Mauritius and the neighbouring island of la Réunion, the white palm or 'Dictyosperma album' is among the tallest palm trees. Its flower is edible, but we have to be patient because it takes five years for the delicious bloom to reach maturity.

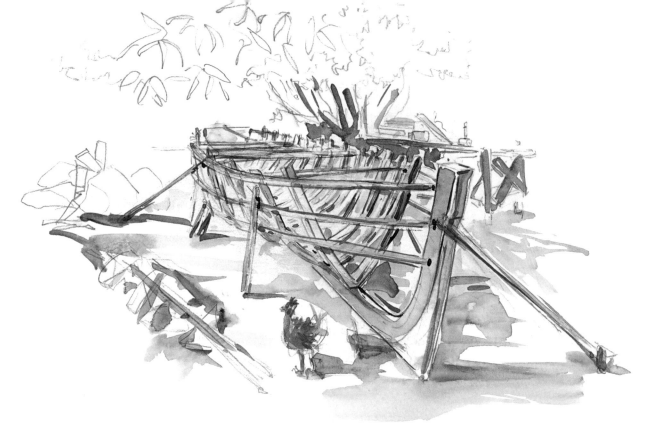

Building pirogues and other boats with full or partial decks
is one of the specialities of the seaside village of Grand-Gaube.
The building techniques are passed down from father to son, a tradition
dating from the eighteenth century when there were many shipwrights working
in the thriving naval industry. Creole furniture makers also owe much
to the know-how of those shipwrights of long ago and their woodworking expertise.

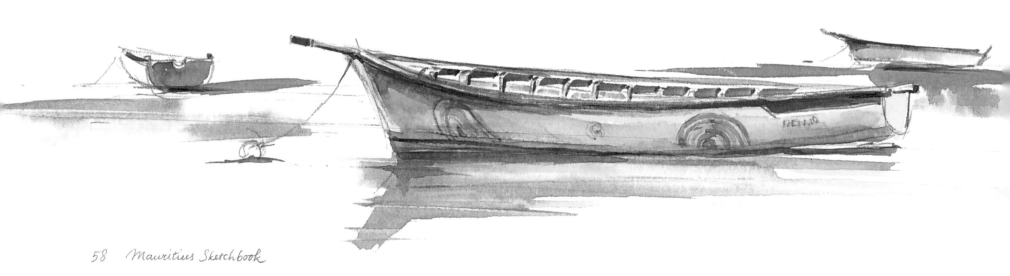

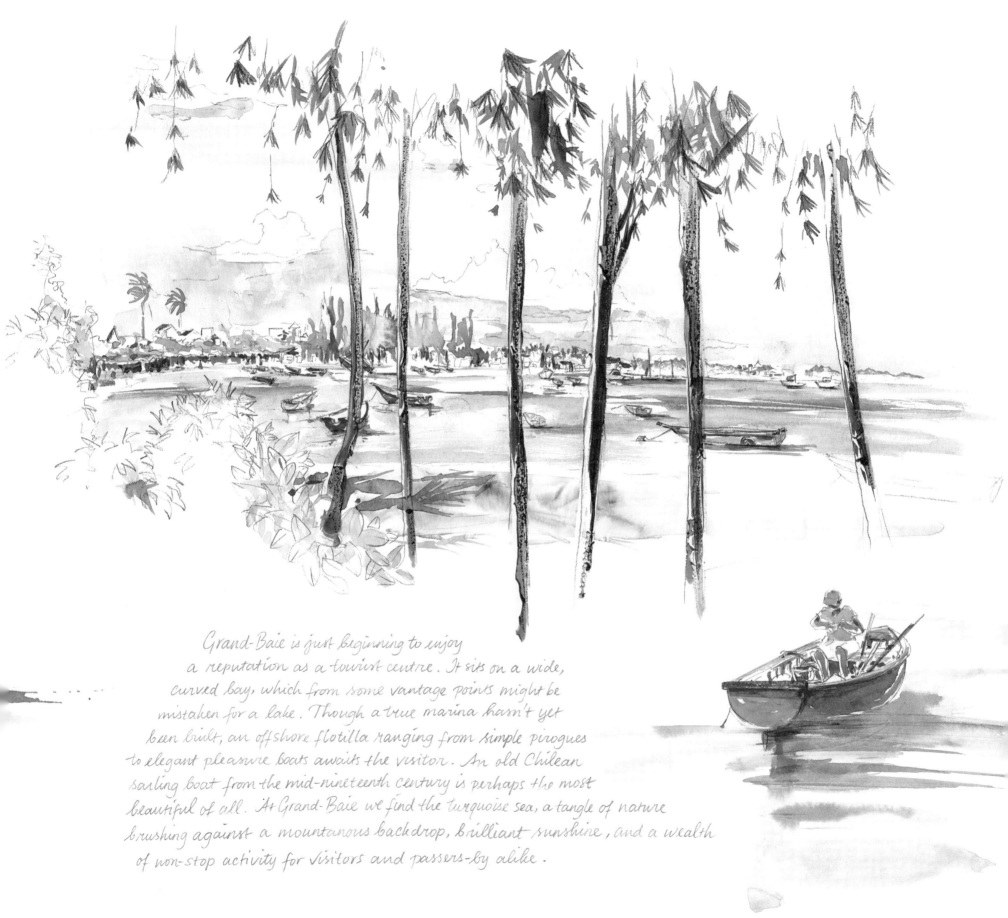

Grand-Baie is just beginning to enjoy
a reputation as a tourist centre. It sits on a wide,
curved bay, which from some vantage points might be
mistaken for a lake. Though a true marina hasn't yet
been built, an offshore flotilla ranging from simple pirogues
to elegant pleasure boats awaits the visitor. An old Chilean
sailing boat from the mid-nineteenth century is perhaps the most
beautiful of all. At Grand-Baie we find the turquoise sea, a tangle of nature
brushing against a mountanous backdrop, brilliant sunshine, and a wealth
of non-stop activity for visitors and passers-by alike.

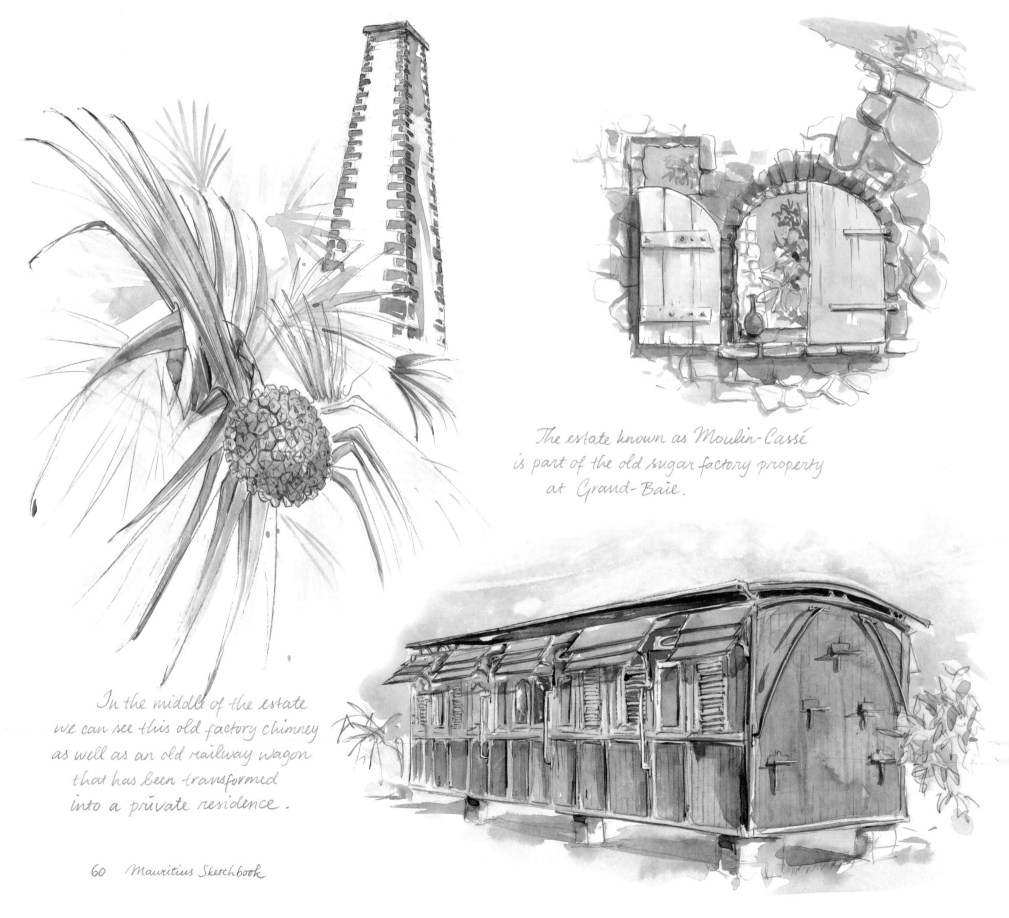

The estate known as Moulin-Cassé
is part of the old sugar factory property
at Grand-Baie.

In the middle of the estate
we can see this old factory chimney
as well as an old railway wagon
that has been transformed
into a private residence.

The estate was entirely renovated during the 1980s,
and is still carefully maintained by the current owners.

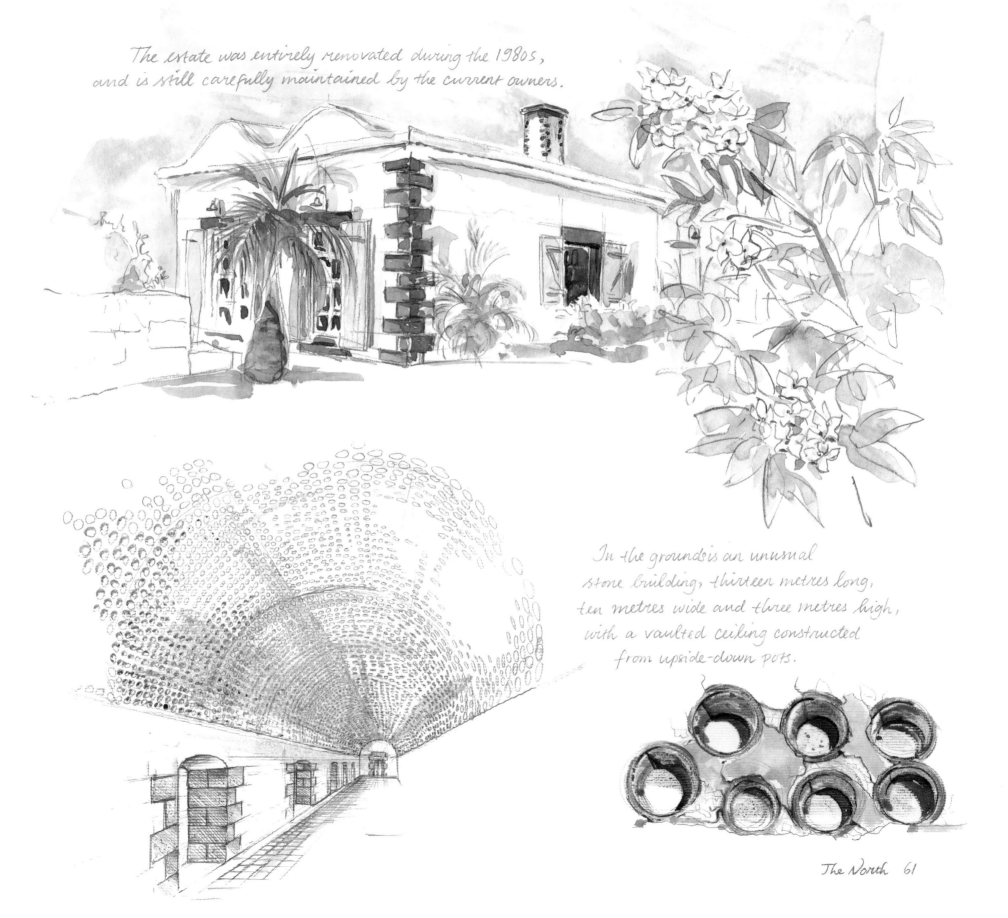

In the grounds is an unusual
stone building, thirteen metres long,
ten metres wide and three metres high,
with a vaulted ceiling constructed
from upside-down pots.

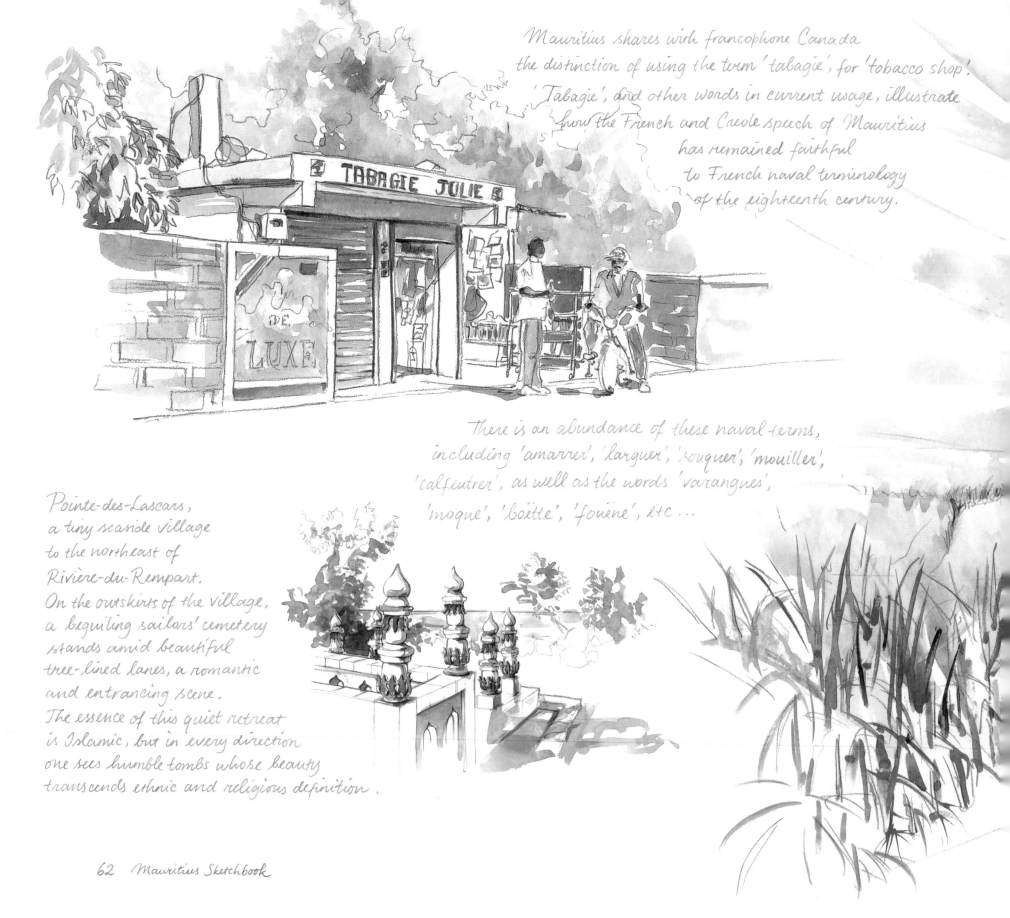

Mauritius shares with francophone Canada
the distinction of using the term 'tabagie', for 'tobacco shop'.
'Tabagie', and other words in current usage, illustrate
how the French and Creole speech of Mauritius
has remained faithful
to French naval terminology
of the eighteenth century.

There is an abundance of these naval terms,
including 'amarrer', 'larguer', 'souquer', 'mouiller',
'calfeutrer', as well as the words 'varangues',
'moque', 'boëtte', 'fouène', etc...

Pointe-des-Lascars,
a tiny seaside village
to the northeast of
Rivière-du-Rempart.
On the outskirts of the village,
a beguiling sailors' cemetery
stands amid beautiful
tree-lined lanes, a romantic
and entrancing scene.
The essence of this quiet retreat
is Islamic, but in every direction
one sees humble tombs whose beauty
transcends ethnic and religious definition.

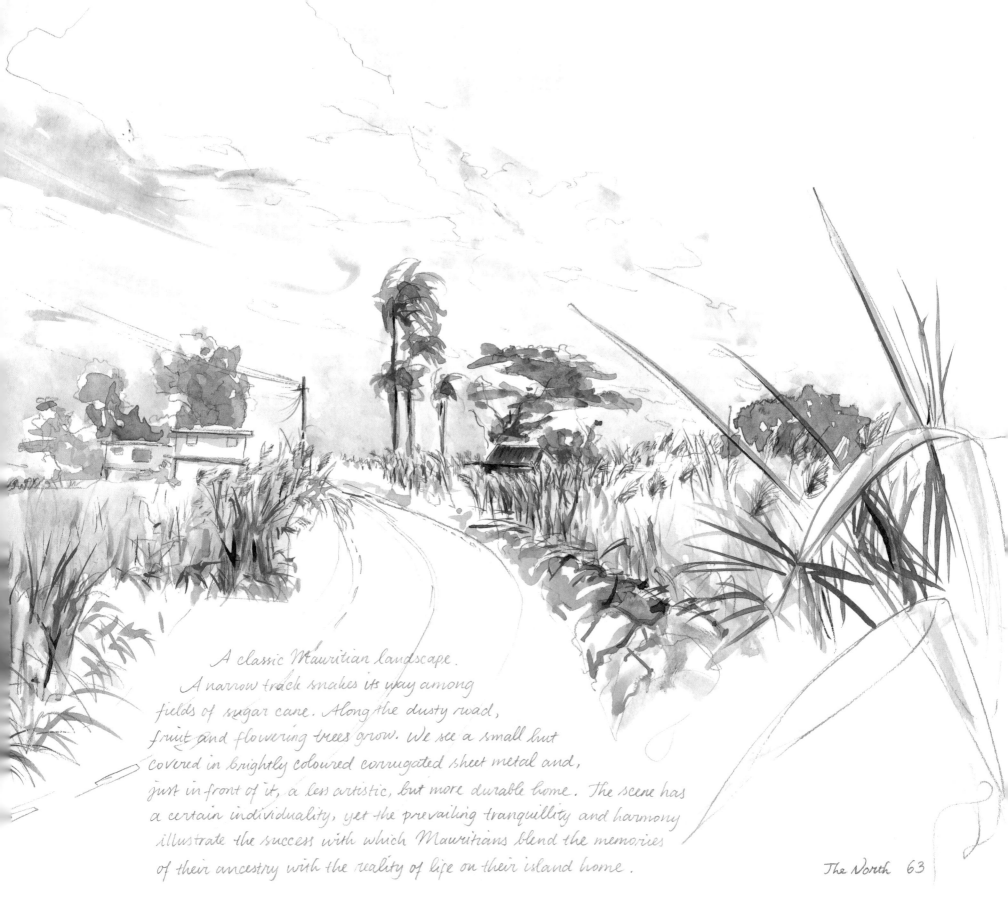

A classic Mauritian landscape.
A narrow track snakes its way among
fields of sugar cane. Along the dusty road,
fruit and flowering trees grow. We see a small hut
covered in brightly coloured corrugated sheet metal and,
just in front of it, a less artistic, but more durable home. The scene has
a certain individuality, yet the prevailing tranquillity and harmony
illustrate the success with which Mauritians blend the memories
of their ancestry with the reality of life on their island home.

The South and the West

The Pointe-aux-Caves
lighthouse, standing on small
basalt cliffs facing
the strong northwest swells.
The only active lighthouse
on Mauritius, it works
in partnership with
the lighthouse on Plate,
an islet to the north.
For sailors and mariners,
they signal the end of
the voyage from Europe
to the Indian Ocean,
as well as safe harbour
on the route between Africa
and Southeast Asia,
or Durban and Perth.

Until the British arrived, the remote and almost inaccessible southern savannah remained primitive and undeveloped. Access from the west was nearly impossible, as there was no way to ford the river at Baie-du-Cap, at Macondé. From the east, local footpaths reached a dead end at the rivers flowing through the ravine bottoms, while to the north, kilometres of humid, impenetrable forest separated the savannah from Port-Louis. Prevailing winds made reaching the southern coast from the sea treacherous. The adventurous colonists who finally succeeded in reaching the savannah were to enjoy a delightful landscape, its mild and pleasant plains, its hills and valleys climbing gently toward the highlands.

The Dutch settled at Black River, which they reached by sea from the west. Along the coast between Morne Brabant and Port-Louis, you can see the breakers through which the Dutch sailed to Black River. The French came next, establishing both a military and an agricultural presence in the southwest. However, they were to find the region unfavourable to development for it was impossible to communicate with the rest of the island, and they lacked adequate irrigation for the fields. The sugar-cane industry thus grew more slowly here than in other regions on the island. It wasn't until 1830 that sugar-cane acreage in the southwest surpassed that of manioc, grain, cotton and other commodities.

In 1639 the Dutch introduced the Java deer to Mauritius. Perfectly adapted to the Mauritian climate, the deer spread rapidly from Grand-Port to other areas. The ecosystem of the

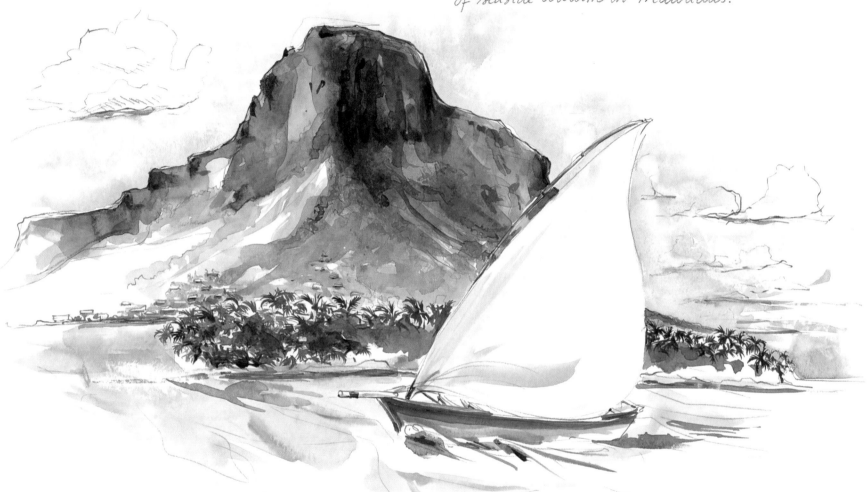

A mythical mountain: Morne Brabant. Revered as a sacred place by many, this exceptional site is also the birthplace of seaside tourism in Mauritius.

West was almost perfect for them, and today you will find many hunting reserves (*chassés*) here. Swordfish are plentiful off the Black River coast. An emerging sport-fishing industry profitably blends sport and business. Today, many fishing centres let tourists test themselves against the giants of the sea: tuna, shark, swordfish, marlin, and sometimes the emperor fish. If you are lucky enough to hook one of these superb specimens – which may weigh as much as 500 kilos (1100 pounds) – your record can be officially ratified, as long as you have hauled your catch on board without the assistance of a crew member. Black River, a sporting paradise of hunting, fishing, mountains, golf and sun has of necessity generated a flourishing hotel industry. Thanks to its delightful setting on the Morne peninsula, Black River has become the main centre for seaside tourism in Mauritius.

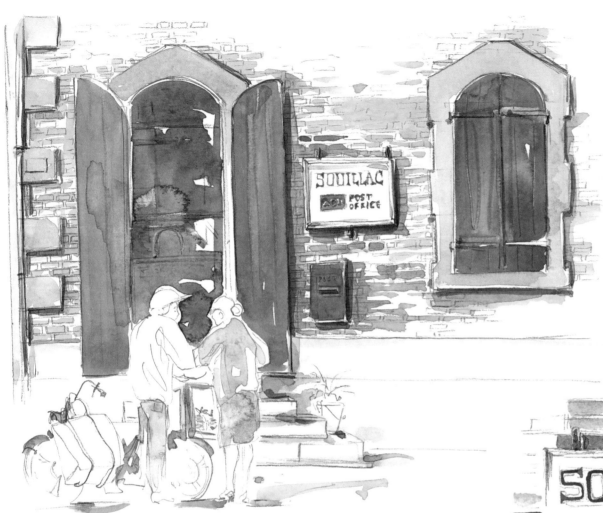

Souillac, a coastal village on the southern shore
of Mauritius, is an especially enchanting spot with Gris-Gris beach,
Telfair Garden, an eighteenth-century military post, the lava
columns of the Rochester waterfall, churches and temples,
a nineteenth-century sugar factory chimney, the old red-brick
English post office, boat moorings, and enormous barges
used to haul sugar to Port-Louis...

A graveyard for old boats, some of which look like
relics of centuries gone by. Look past the faded hulls,
over the raging waves, and beyond the horizon lies the South Pole.

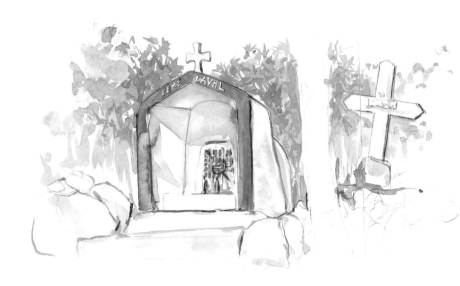

The Mauritians are fond of small
outdoor shrines. Catholic altars dedicated
to Sacré-Cœur or to the Virgin Mary stand
next to religious shrines covered with small
statues of Hindu deities responsible for the protection
of the family. Nearby are other 'Kalimayes',
small sanctuaries dedicated to the goddess Kali.

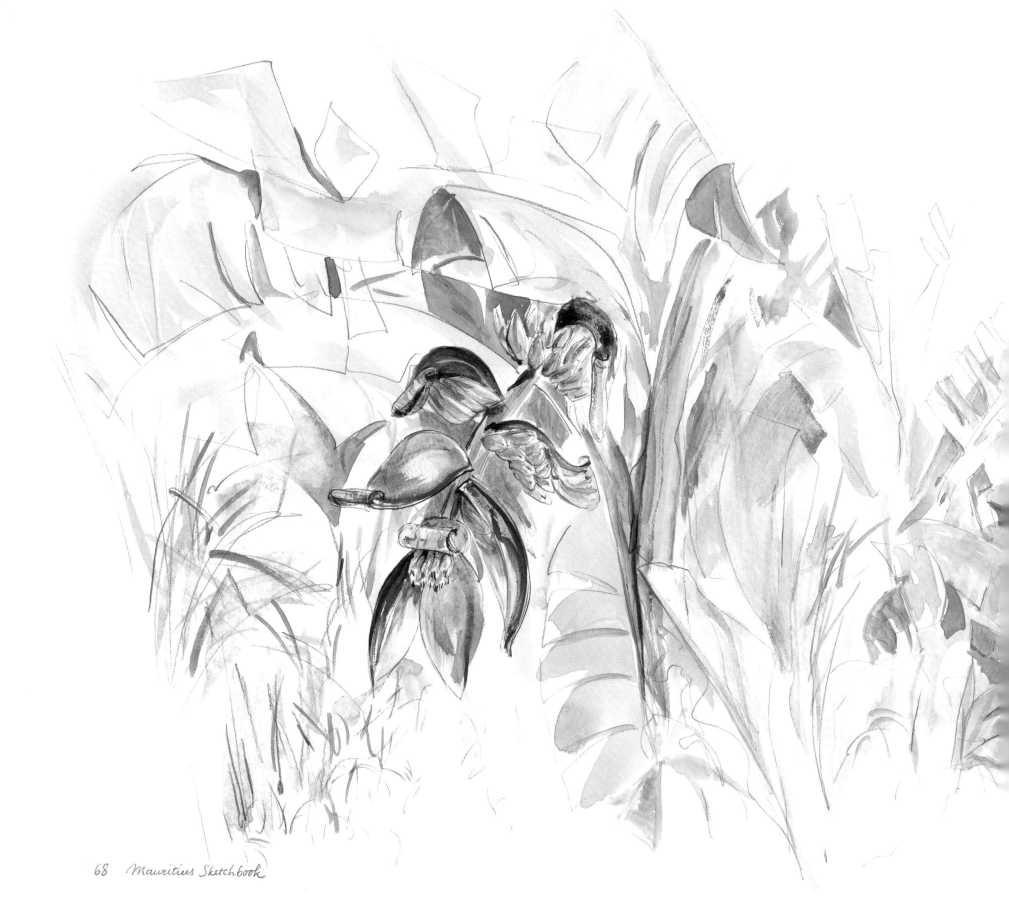

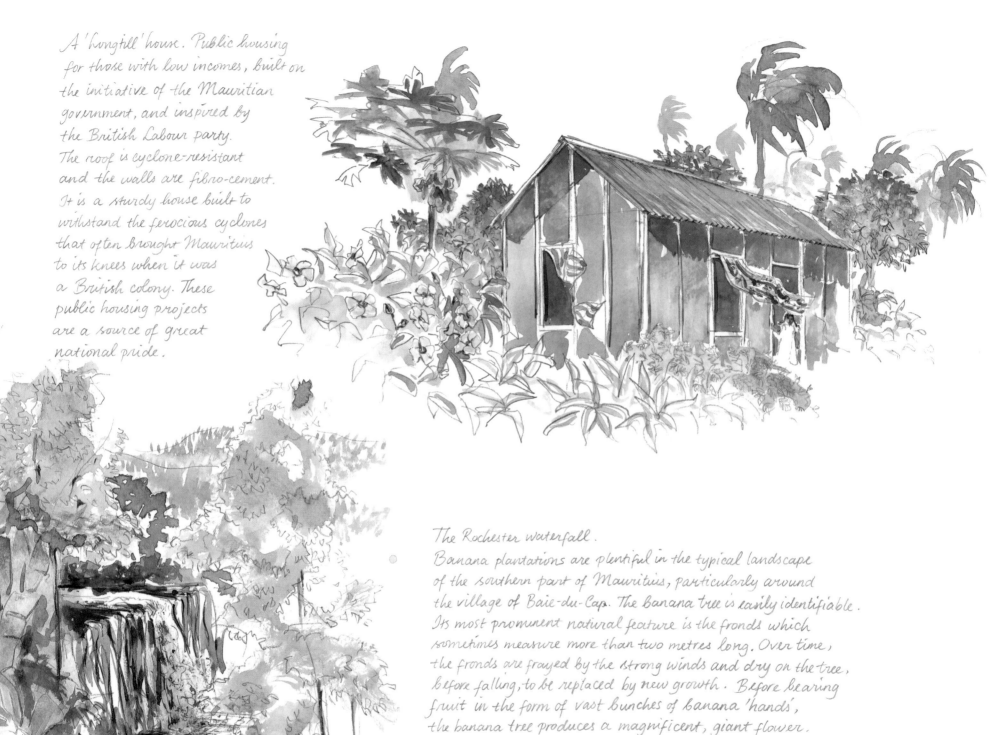

A 'longfill' house. Public housing for those with low incomes, built on the initiative of the Mauritian government, and inspired by the British Labour party. The roof is cyclone-resistant and the walls are fibro-cement. It is a sturdy house built to withstand the ferocious cyclones that often brought Mauritius to its knees when it was a British colony. These public housing projects are a source of great national pride.

The Rochester waterfall.
Banana plantations are plentiful in the typical landscape of the southern part of Mauritius, particularly around the village of Baie-du-Cap. The banana tree is easily identifiable. Its most prominent natural feature is the fronds which sometimes measure more than two metres long. Over time, the fronds are frayed by the strong winds and dry on the tree, before falling, to be replaced by new growth. Before bearing fruit in the form of vast bunches of banana 'hands', the banana tree produces a magnificent, giant flower. Its crimson petals gradually open, revealing the promised bananas. The glorious banana tree is one of nature's most extravagant statements.

The village shopkeepers boast that they sell everything and can find anything if their customer needs it. The shopkeeper continues to occupy an important, supportive role in the village. He is simultaneously banker, pawnbroker, intermediary, real estate broker, and innkeeper. A man for all purposes, offering credit where it is needed: drinks to men, and food to women and children. Villagers will settle their accounts with the 'Bon Dieu', as the shopkeeper is known, as soon as they are able, secure in the knowledge that he will wait until they are able to repay what they owe him.

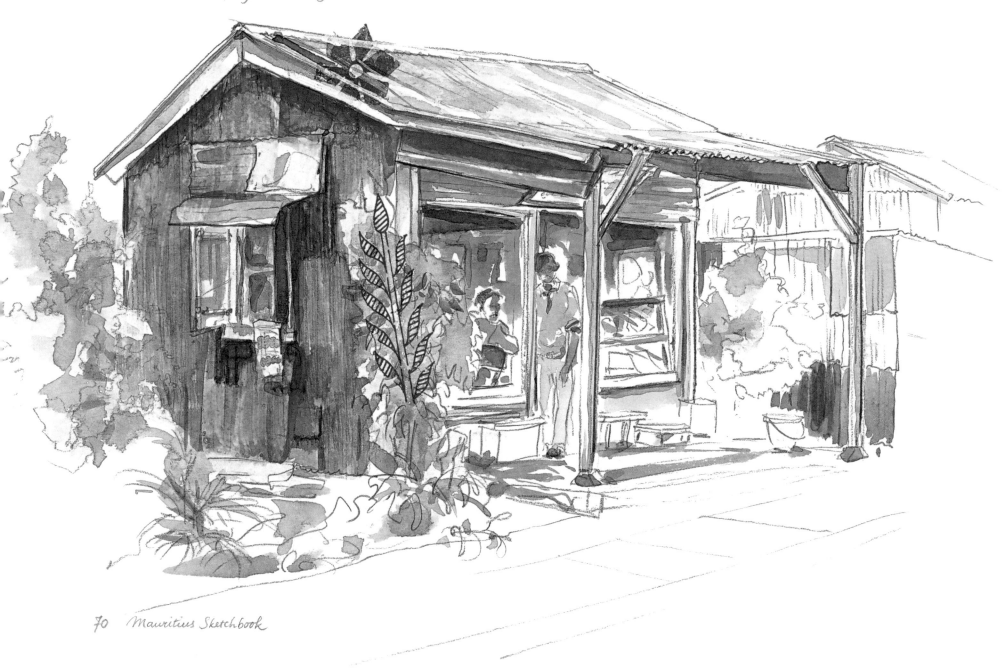

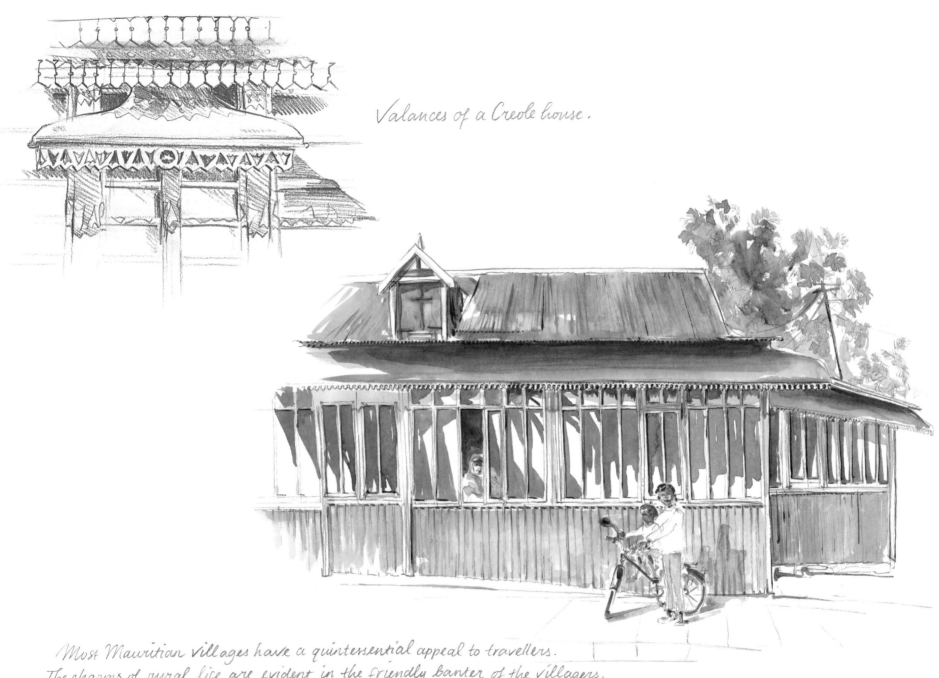

Valances of a Creole house.

Most Mauritian villages have a quintessential appeal to travellers.
The charms of rural life are evident in the friendly banter of the villagers,
in town where it seems that everyone knows each other. We find the real
meaning of Mauritian unity in these small clusters of homes. Whether you
live in a modest Creole house, with a windowed veranda and brightly
coloured corrugated tin roof, or whether you run a small business and
live above the store, what's most important is that you are part of a village
with one purpose: to be a place where everyone feels at home, and where
no belief that might offend a neighbour is held too dear.

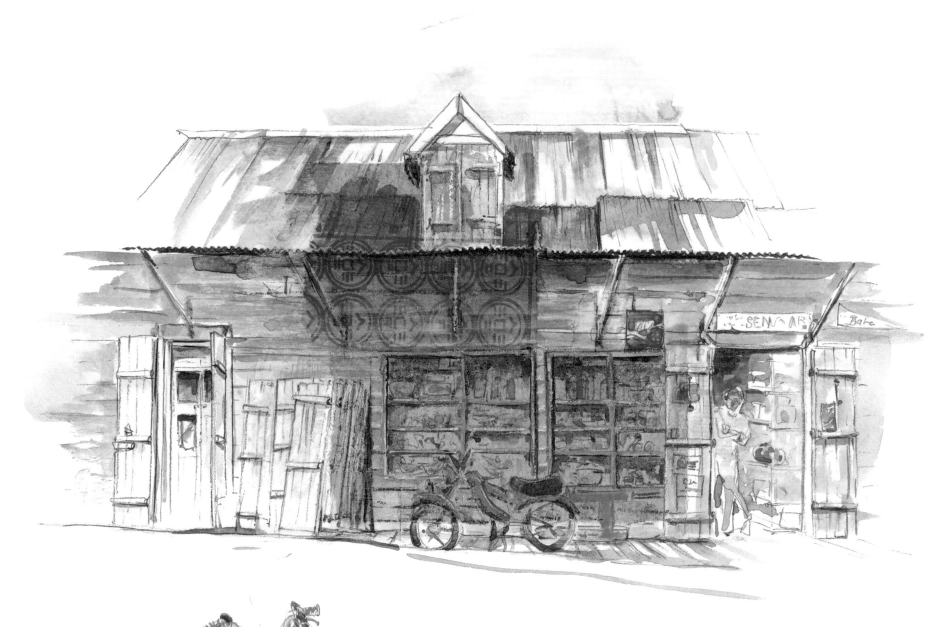

Not too long ago Mauritians were unappreciative
of shopping centres and department stores. Today, these large
modern enterprises are regarded with a mixture of pride
and envy. Unlike the village shop though, these temples
to commerce require proper dress and, more importantly,
cash payment for purchases.

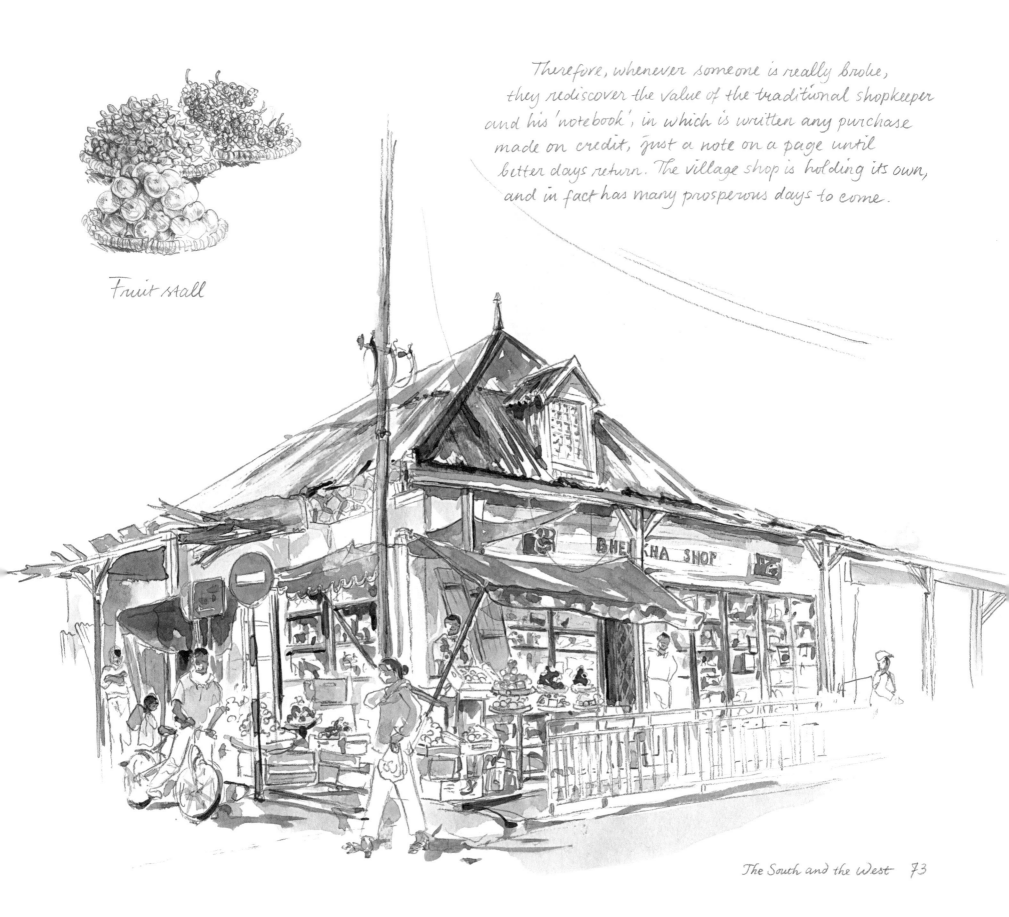

Fruit stall

Therefore, whenever someone is really broke, they rediscover the value of the traditional shopkeeper and his 'notebook', in which is written any purchase made on credit, just a note on a page until better days return. The village shop is holding its own, and in fact has many prosperous days to come.

The Centre

The Plaines-Wilhems region constitutes an urban corridor through the middle of the island, twenty kilometres (twelve miles) long and six kilometres (three-and-a-half miles) wide. Three out of ten Mauritians live in this area, now one of the most densely populated on the island. Visitors who know little of the island's history find it hard to believe that these highlands were once some fifty years behind the coastal regions in population growth and economic development. While access to Moka was relatively easy from Port-Louis and Flacq, massive annual flooding made it difficult to reach the rest of the region, effectively isolating it for many years. The first catholic parish of Saint-Jean was established in

1847, a full 126 years after that of Saint-Louis and Notre-Dame-des-Anges at Grand-Port (1722), and a century after Saint-Francis of Assisi at Pamplemousses (1743).

The central region was finally rescued from underdevelopment thanks to the laying of a railway line in 1864, which crossed the region in stages, ultimately linking Port-Louis to Mahébourg. A second important factor that led to the colonization of this high-lying area (elevation 800–1600 feet), was the malaria epidemic of 1867. Malaria, returning each year, was not controlled until 1948, when the mosquito that carried the virus was eradicated by the use of DDT, a powerfully effective, but unfortunately harmful, insecticide. Malaria affected the coastal areas most. Wealthy families affected by this pernicious disease fled the coast in the malaria season to take refuge in the central highlands. Because of this, between 1830 and 1900 Curepipe was transformed from a simple hillside stagecoach stop, surrounded by marshes, to a delightful city, administered by an urban council with municipal powers. It became Mauritius' second-most-important city.

Today, more than 350,000 Mauritians live in the Plaines-Wilhems. The earliest villages have become homes to thousands of people from Africa, Europe, India, and China, believers in Jesus Christ, Allah, Buddha or the multitude of Hindu divinities. They speak in many languages and subscribe to different traditions. Their differences create a society immeasurably enriched by diversity. All these people live as brothers and sisters, greeting 700,000 visitors a year as welcome friends.

The Curepipe town hall: 'Paul and Virginie', a bronze sculpture by Mauritian Prosper d'Épinay.

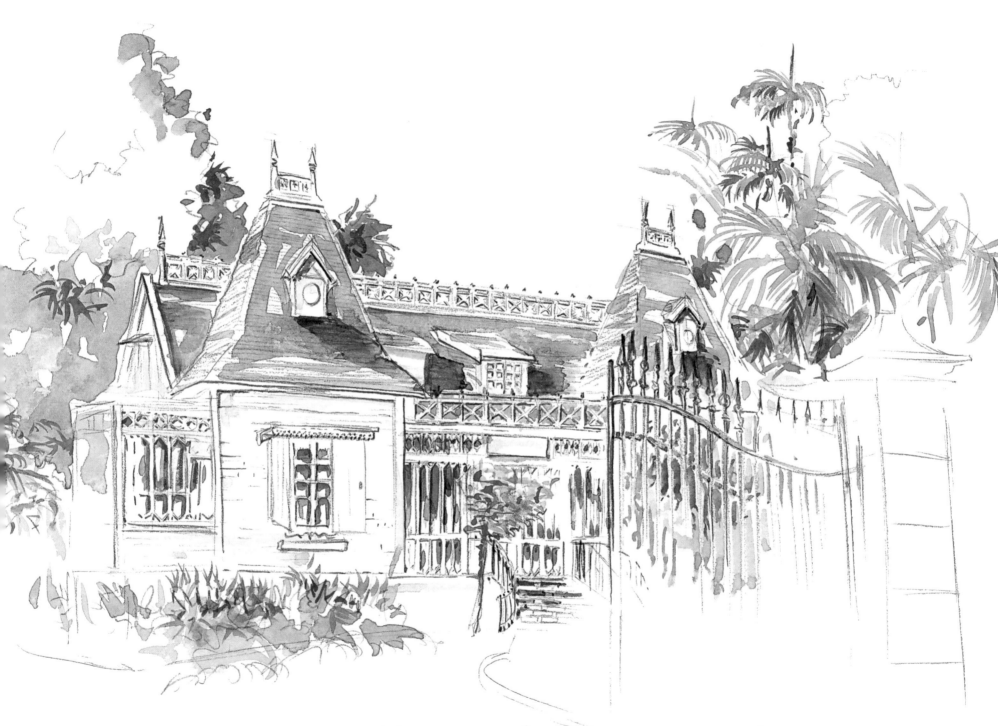

A Creole house, in Gustave-Bestel Street, Curepipe. Sophisticated and refined, it is one of the most elegant examples of Mauritian architecture.

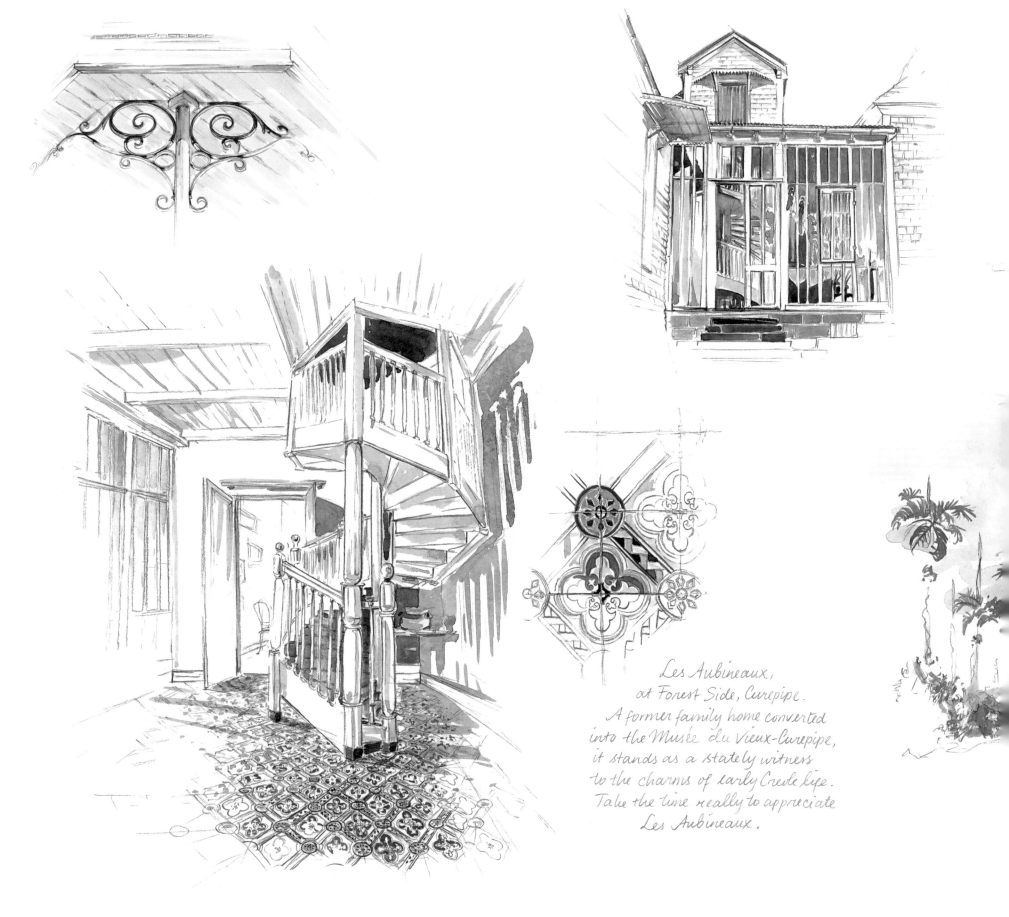

Les Aubineaux,
at Forest Side, Curepipe.
A former family home converted
into the Musée du Vieux-Curepipe,
it stands as a stately witness
to the charms of early Creole life.
Take the time really to appreciate
Les Aubineaux.

Take a leisurely stroll along the lovely open veranda,
enjoy the various sitting rooms, the two porches—one for the summer
and the other for rainy winter days, the large family breakfast
room, the linked corridors (the first on the island), the home office,
the old wooden staircase leading to the second-floor bedrooms,
the vast attic with its thousand treasures, and the heart
of the house, the billiard room. The roof is a wide expanse,
maintained to look just as it did long ago.
Les Aubineaux is a ticket guaranteed
to transport you to the nineteenth century.

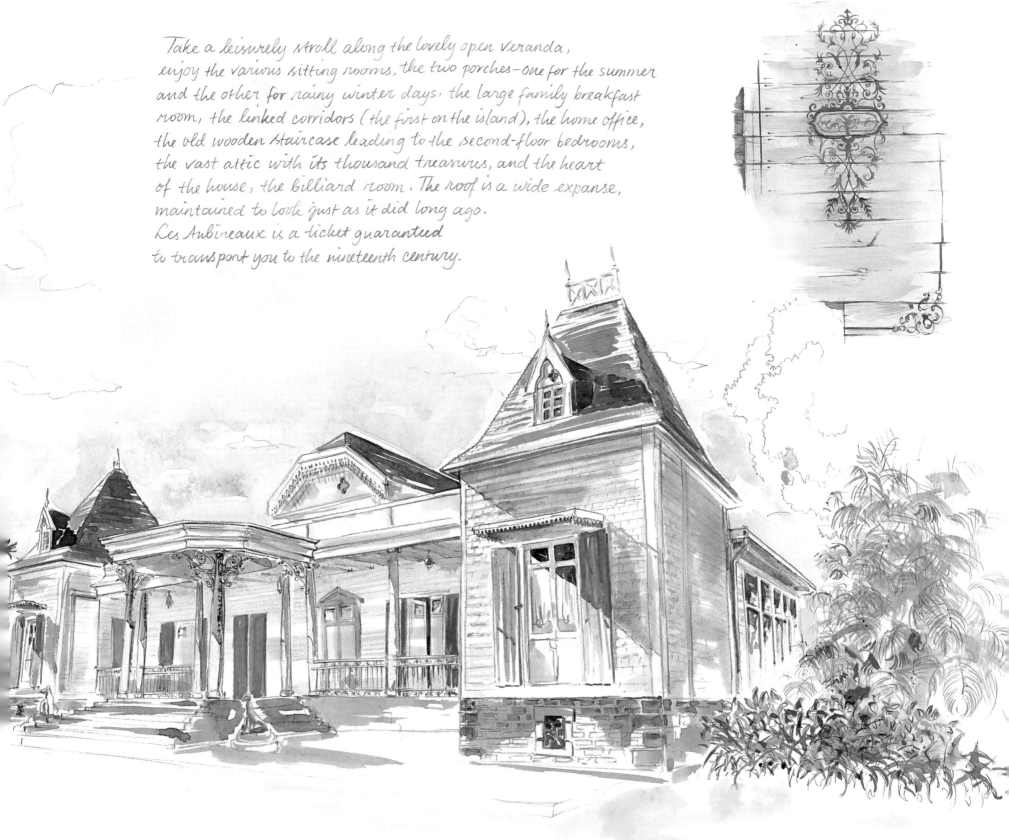

A jasmine flower.

'Palmiste gargoulette'

The nineteenth-century French writer
and humourist Alphonse Allaï showed
great foresight, for he dreamed of building
cities in the countryside where urbanites could
breathe fresh country air. In Mauritius though,
one never truly knows where the countryside begins
and the city ends. Except for the city of Port-Louis
and the town of Mahébourg, what pass for city centres
here are born at the intersections of forest trails
and paths through the sugar cane fields, though they've
long since broadened with use into streets,
avenues and boulevards.

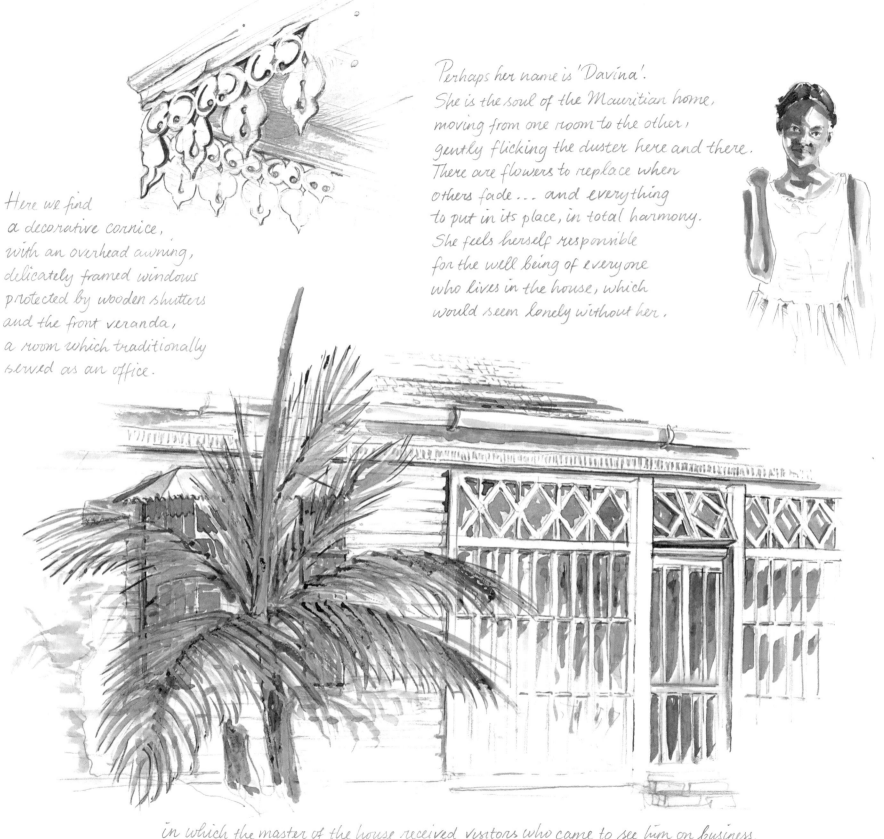

Here we find
a decorative cornice,
with an overhead awning,
delicately framed windows
protected by wooden shutters
and the front veranda,
a room which traditionally
served as an office.

Perhaps her name is 'Davina'.
She is the soul of the Mauritian home,
moving from one room to the other,
gently flicking the duster here and there.
There are flowers to replace when
others fade... and everything
to put in its place, in total harmony.
She feels herself responsible
for the well being of everyone
who lives in the house, which
would seem lonely without her.

in which the master of the house received visitors who came to see him on business.
Small details like these added to the charm of the Creole life.

Brij Ramlagan, the 'national' hardware store
on the road from Club to Vacoas, is an important resource
for residents in the neighbourhood. The shopkeeper can make
everything to order and in only twenty-four hours, so why form
something out of plastic when it can be made in galvanized tin?

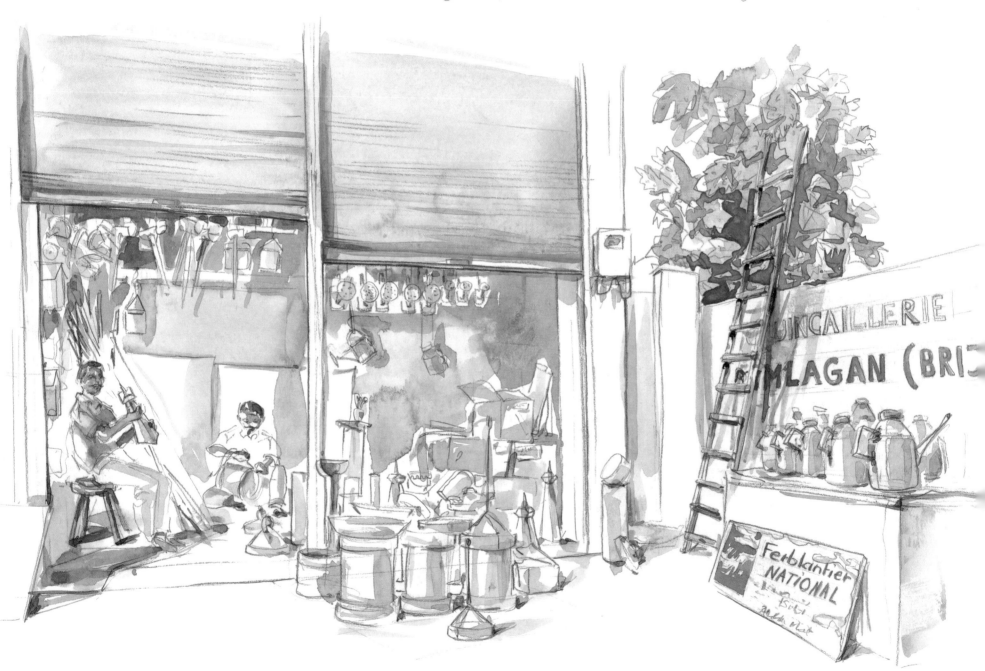

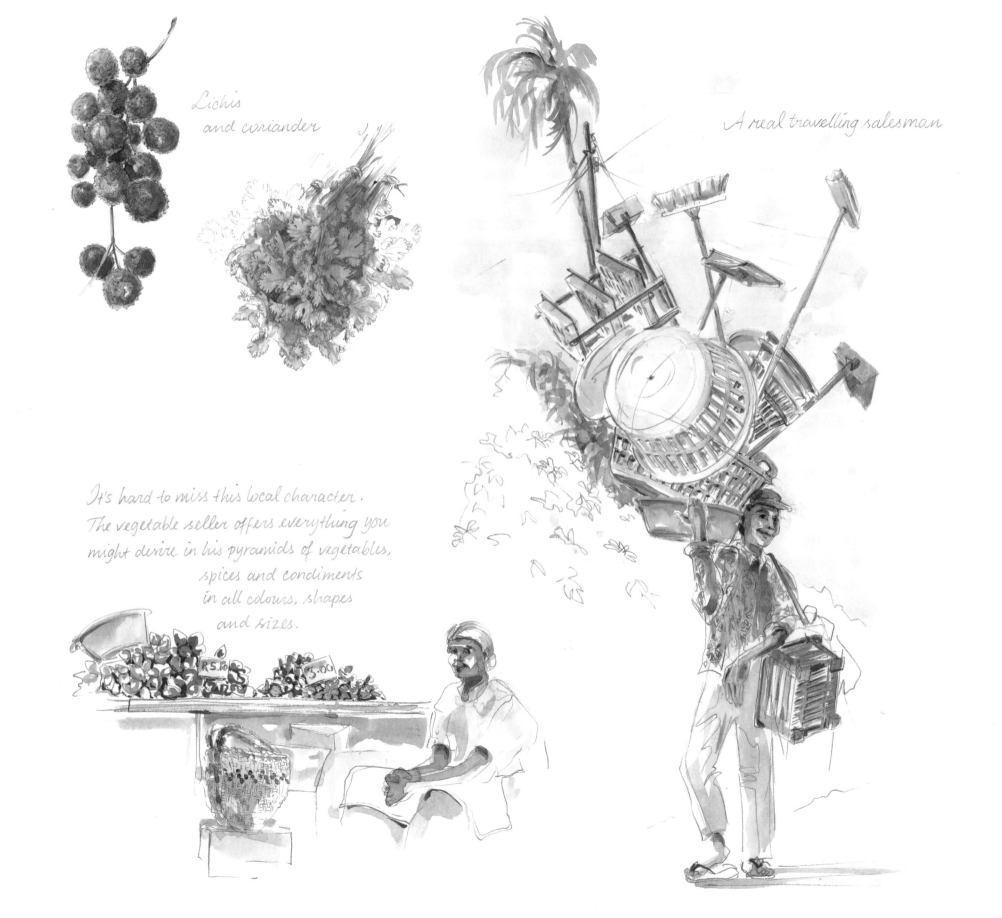

Lichis
and coriander

A real travelling salesman

It's hard to miss this local character.
The vegetable seller offers everything you
might desire in his pyramids of vegetables,
spices and condiments
in all colours, shapes
and sizes.

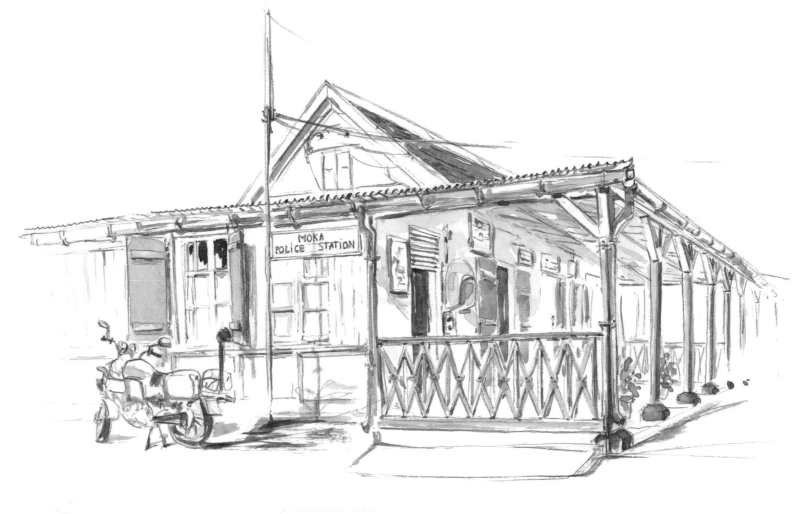

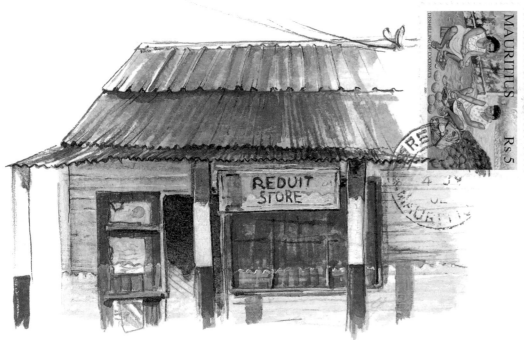

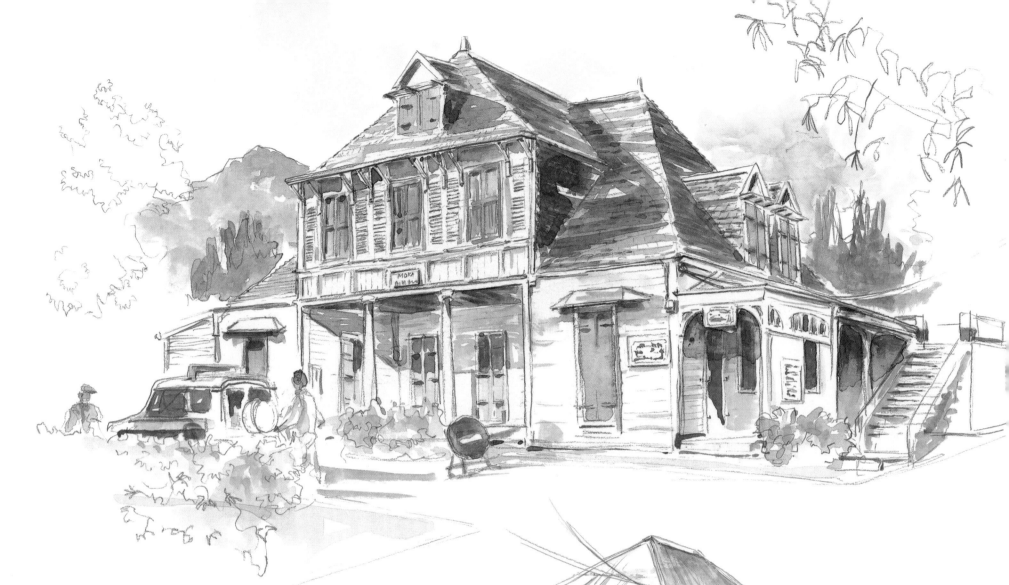

A charming group of buildings,
housing the public offices, police station
and general headquarters for the Moka police,
with an annexe on the corner. Together they
create a beautiful example of Creole architecture.
What a curious picture though, an elegant
residence adorned with road signs
and official notices.

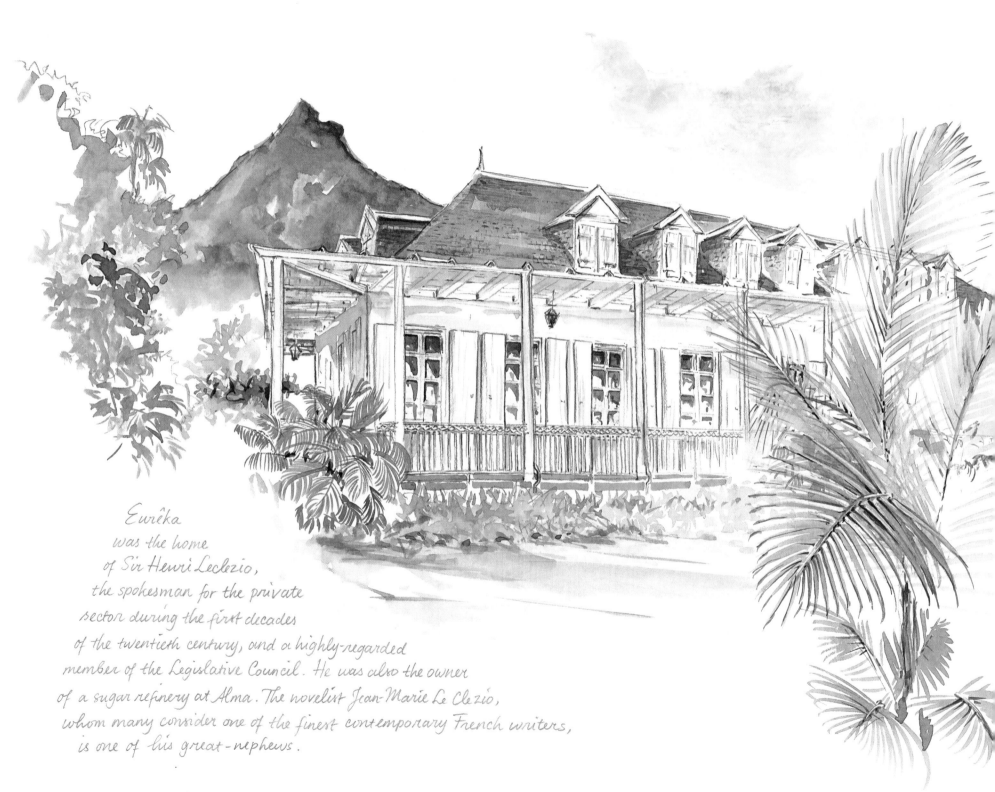

Eurêka
was the home
of Sir Henri Leclezio,
the spokesman for the private
sector during the first decades
of the twentieth century, and a highly-regarded
member of the Legislative Council. He was also the owner
of a sugar refinery at Alma. The novelist Jean-Marie Le Clezio,
whom many consider one of the finest contemporary French writers,
is one of his great-nephews.

Eurêka permits visitors
a glimpse of Mauritian life
at the beginning of the twentieth century,
at a time when running water, telephones,
and electricity weren't as widely available
as they are today. Here are interesting
appliances and other precursors to the gadgets
that simplify our lives today.

The Montmartre church at Rose Hill,
dedicated to the worship
of the Sacred Heart of Jesus Christ,
through the sacrament of the eucharist.
Built in 1940, along plans conceived
by the painter-architect Max Boullé,
it is managed by the religious
congregation of the
Marie Réparatrice society.
Its fine, slender, concrete steeple
has a simple elegance.

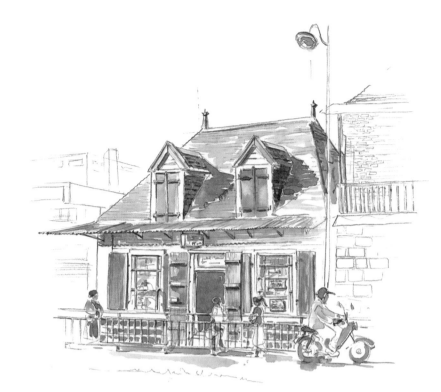

A drugstore at Rose Hill.

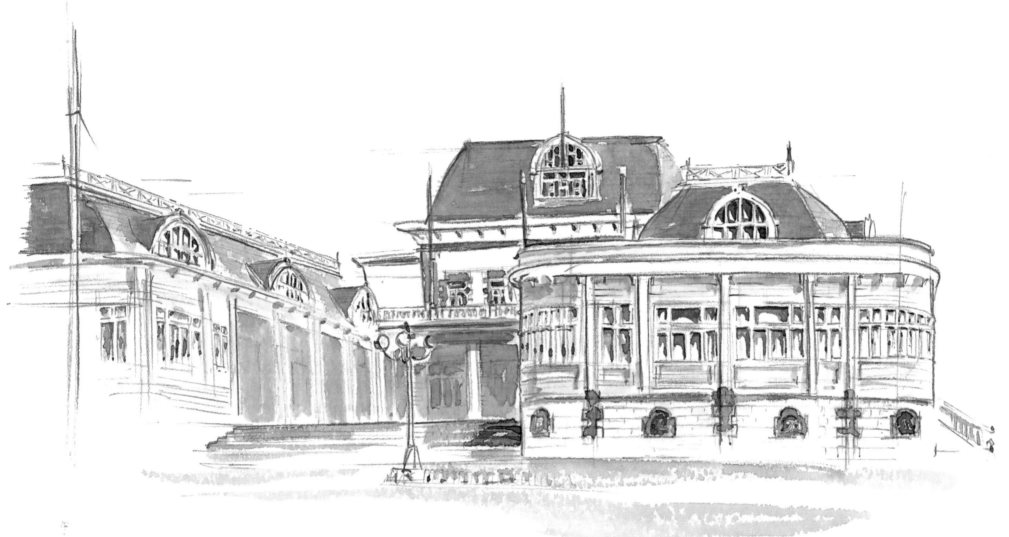

The town hall for the sister cities of Beau-Bassin
and Rose Hill includes a municipal theatre known
to all Mauritians as the 'Plaza'. Located behind
the theatre is an interesting theatre museum.

The Rose Hill post office reminds us, as do
the administrative offices of Centre-de-Flacq,
how much the early British administrators
missed their native land, and tried to recreate
miniature reminders of Great Britain
on the distant island of Mauritius.

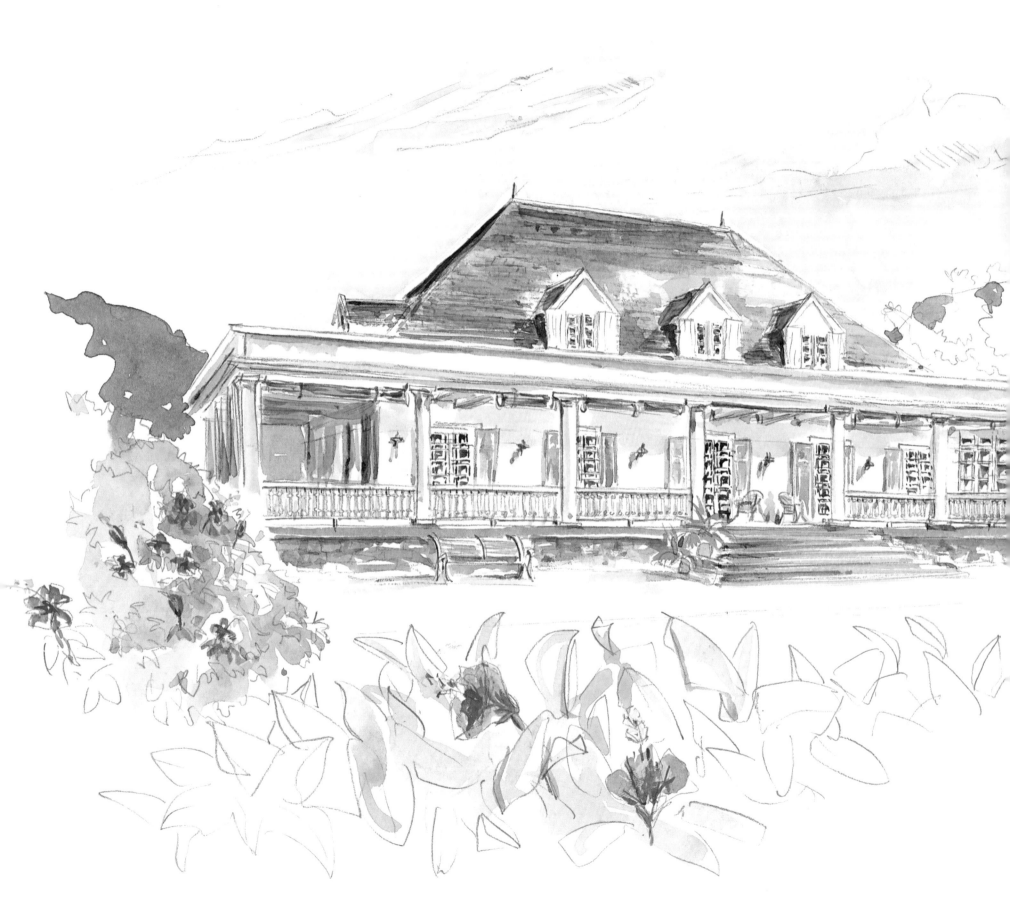

Le Clos Saint-Louis, the flagship
of the eighteenth-century Les Pailles estate
at Anse Courtois, is the result of a recent, ambitious
renovation project for the former sugar cane plantation.
Built to attract and promote tourism, it includes restaurants,
a casino, ballrooms and conference rooms, stables, orchards,
a vegetable garden, a miniature railway, horseback
or jeep rides to the mountain, carriage rides,
and in the summer a simple sugar refinery,
where the sugar cane is ground
by animal-powered mills.

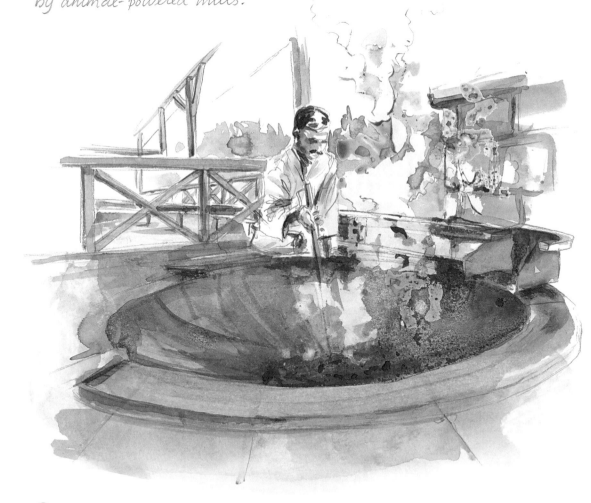

Sugar-cane

Rodrigues

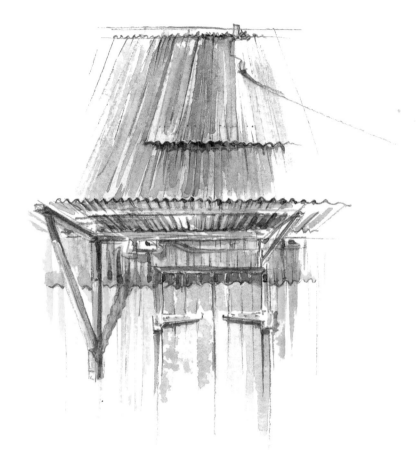

In Mauritius the influence and contribution of external powers has been continuous since its earliest days. Its citizens have always been well-organized and intent on making their own points of view known. In contrast, distant Rodrigues has relied primarily on its own resources for survival. Despite this, until recently, important decisions pertaining to Rodrigues' welfare were often made by politicians and bureaucrats with a limited and inadequate understanding of the problems, aspirations and potential of the citizens of Rodrigues. Before independence from Mauritius in 1968, it was London, via its colonial functionaries in Mauritius (influenced by the few Rodrigians in whom they had confidence), who decided what was allowed or denied to the 30,000 island residents. It was just too bad for the latter if the decisions taken on the banks of the Thames conflicted with the vital interests of the island's people.

Rodrigues is located more than 550 kilometres (340 miles) from Mauritius. Before the 1970's, connections between the two were made by sea, with a sailing once a month or perhaps every six weeks. On Rodrigues, there was no source of drinking water, no electricity, no public transportation, no public health care, the risk of medical emergencies, and long periods of isolation. A civil-service posting to Rodrigues was not high on anyone's list, unless he or she was a glutton for punishment. Its remoteness and isolation explains how time seems to have stopped on Rodrigues for so long, obliging the island to develop its own rhythm. Today everything is changing. Air travel has brought Rodrigues within easy reach of the rest of the world; yet there is still much to accomplish. Although Rodrigues now has radio, television, telephone, even mobile phones and the Internet, it could still benefit from better infrastructure and public services. Tourism has also arrived and may some day be the foundation of the Rodrigian economy. And, since September 2002, Rodrigues has finally been granted a regional autonomous government.

For the first time in their five-hundred-year history Rodrigians have the right to make their own decisions about what is good for Rodrigues. At long last, the citizens of Rodrigues hold their destiny in their own hands, and anything seems possible.

For many long years it seemed that time had stopped
on the island of Rodrigues. The passing years had no hold
over the inhabitants of this remote island, who continued
to enjoy an older, simpler rhythm of life. The arrival
of greater and greater numbers of tourists,
and the establishment of a regional, autonomous
governing body that appears to respect local needs,
are enabling Rodrigues to make up for lost time,
though not to the detriment of the traditional
Rodrigian lifestyle.

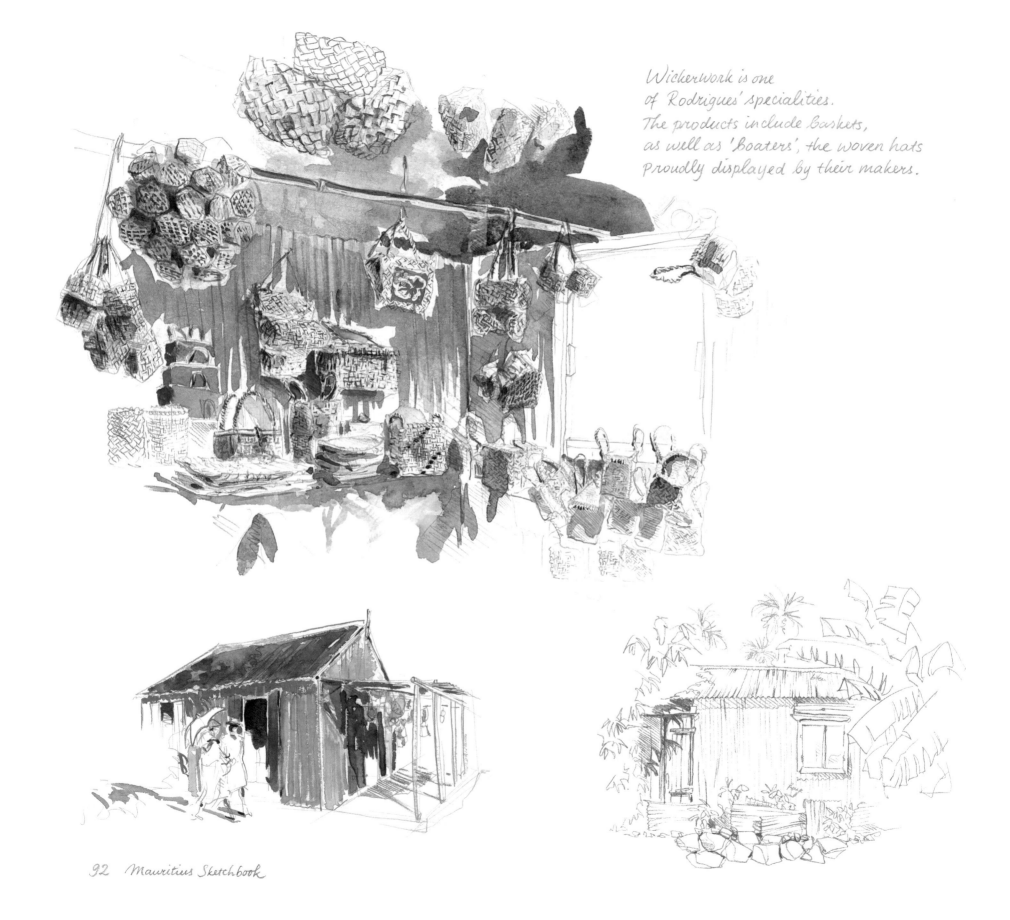

Wickerwork is one
of Rodrigues' specialities.
The products include baskets,
as well as 'Boaters', the woven hats
proudly displayed by their makers.

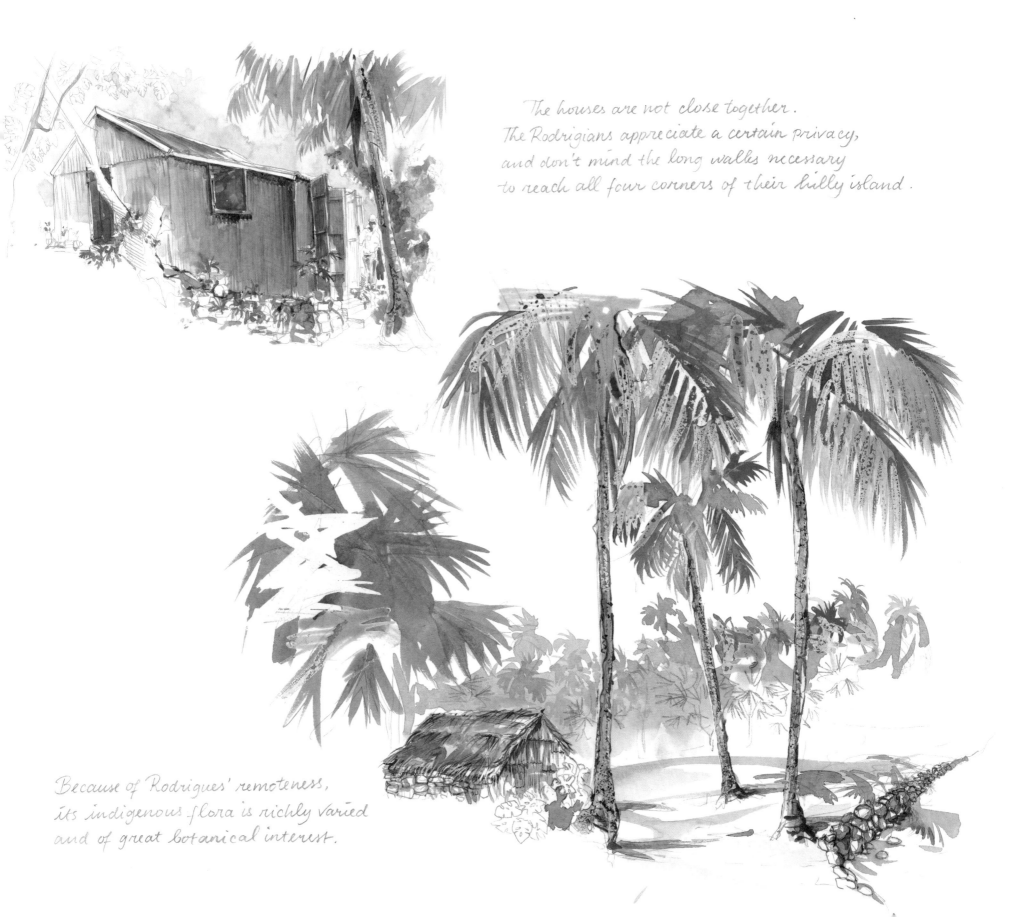

The houses are not close together.
The Rodrigians appreciate a certain privacy,
and don't mind the long walks necessary
to reach all four corners of their hilly island.

Because of Rodrigues' remoteness,
its indigenous flora is richly varied
and of great botanical interest.

Recommended Itineraries

1. PORT-LOUIS ON FOOT

Our walking tour of Port-Louis begins in the Company Garden, in the centre of town, where the Pouce River formerly divided the city in two. The Government House, Treasury and the place d'Armes were all built to the north of the Garden. Port-Louis' commercial centre, built in the 19th century, sits on top of the remains of marine workshops built by La Bourdonnais, and destroyed by fire in 1816.

Next go towards the waterfront. In the old days, there was a beach where the place du Quai is today. The historic port includes the Hôtel de la Poste (1868), the 18th-century windmill, the post office, and the Postal Museum (a public hospital from 1740 to 1899), the 1930's era rice and flour warehouse, the Development Works Corporation building, actually an ancient barracks constructed from quaternary period coral (1.6 million years old), and the Aapravasi Ghat, where more than 400,000 migrant workers from India disembarked between 1830 and 1920.

Taking Pasteur Street, you enter Chinatown. Return to the city centre by Royale Street, stopping in front of the Jummah Mosque and the vibrant, multicultural central market. Continuing, you will head towards the municipal and judicial centre of Port-Louis. Follow Jules-Koenig Street and enjoy shopping at the Poncini store. On Vieux-Conseil Street you find the Photography Museum, the municipal theatre (1812), the Supreme Court, and beyond that the ancient prison, standing in front of Saint-Louis Cathedral and its interesting Creole presbytery. Behind the cathedral is the Episcopal Palace (1853). Continue on foot, going down towards the Anglican cathedral of St. James (19th century), built on the ruins of an old French powder magazine with walls three metres (10 feet) thick.

On reaching the southern rampart of the city, you will find a quiet residential neighbourhood, slowly being nibbled away by offices and shops. Here, too, are the 18th-century main arsenal and Victorian-era iron railway station (1864), built for the trains serving the southern parts of the island. Looking across the road, you see the shorelines of Caudan and Port-Louis, where you can stroll for many miles. On the Caudan waterfront is the Blue Penny Museum and the aquarium (under renovation) housed in an old railway warehouse. There's a wonderful view of the Port-Louis harbour from the shore, but a boat tour of the harbour is highly recommended. Arrange boat tours just in front of La Bourdonnais Hotel, in Caudan.

2. PORT-LOUIS BY CAR

Your starting point is the Quai, where you see the commercial activity of the Mer Rouge free port. Take Nicolay Road, and see the fascinating Tamil temple Meenatchee Sockalingum Amen and the Sainte-Croix Church where you can visit the tomb of 'blessed' Father Laval, Patron Saint of Mauritius. Stop briefly at the Abercrombie police station with its lovely 19th-century military architecture, as you drive along Pamplemousses Road. You will drive right through the Muslim quarter of Plaine-Verte.

Follow Magon Street and Victoria Avenue to take a tour around the Champs-de-Mars racecourse. You will also see the tomb of Governor Malartic (1792-1800) and the statue of Edward VII by the Mauritian sculptor Adrien d'Épinay. Drive to the top of the Petite-Montagne and visit Fort-Adélaide, known as La Citadelle, to appreciate the panoramic view of Port-Louis. Drive back down to the city centre, taking Dauphine Street, Pope-Hennessy Street, La Bourdonnais Street, and Monseigneur-Leen Street. Stop at the monument to Marie-Reine-de-la-Paix, where there is yet another good view of Port-Louis.

You will return by Cassis. Visit Saint-Sacrement, called the Cathedral of the Poor. The Old Cemetery, also called the Western Cemetery, has beautiful 19th-century tombs and sepulchres of well-known figures in Mauritian history. You should visit the Robert Edward Hart garden and the Kouan-Ti Pagoda, a very important shrine for Mauritian Buddhists.

Returning to Port-Louis you pass Grande-Rivière-Nord-Ouest. Don't miss the public beach at Sables Noirs, the old Breton cemetery, the Saint-Louis medieval tower, the old bridge, the Vagrant Depot, where migrant workers were incarcerated if they were found outside their estates without permission, and of course the cultural centre at Les Pailles (see pp. 88-89).

3. THE NORTH COAST

Leaving Port-Louis, take the highway north, and then the exit for Arsenal, after the Terre-Rouge roundabout. Stop at the pottery shop where a master craftsman specializes in making terracotta lamps used especially for the Hindu festival of Diwali. Continue on the B41. Stop in Balaclava at the Maritim Hotel, to view the interesting ruins of a flour-mill and an 18th-century gunpowder works. There are a number of interesting hotels along the way.

Follow the coast road from Pointe-aux-Piments to Trou-aux-Biches. Take a small detour at Triolet to see the Maheswarmath Hindu Temple (1891). At Choisy the meadows and public beach make an attractive stop. Here, too, is the Hilly/Lemerle monument, in memory of two aviation pioneers who disappeared into the sea while exploring the skies over the Indian Ocean in 1933. Arriving at Pointe-aux-Canonniers, you find Club Med and the hotel Le Canonnier, in the grounds of which are preserved remains of a quarantine station and a lighthouse (1855-1932).

Nearby Grand-Baie is the tourist capital of the North. There is a lovely Tamil temple, as well as the modern Saints-Anges church and the old Notre-Dame-de-la-Salette church (1864). Grand-Baie is a recommended departure point for boat trips to Balaclava and Port-Louis. If possible, board the *Isla Mauritia*, a charming 19th-century Chilean ship. An alternative excursion is a boat ride around Coin-de-Mire or as far as the islands Plate and Gabriel (preferably on a catamaran). Grand-Baie is home to the private estate of Moulin-Cassé (see pp. 60-61), an old sugar plantation and factory.

Get out of the car and sunbathe or go swimming at Peyrébère, where the silk-like sand is an unforgettable experience. Next is Cap-Malheureux, with its vermilion-roofed chapel (1938). This is the spot where British troops disembarked in November 1810, to wrest the island from the French.

You arrive next at Grand-Gaube (*gaube* means small bay), a Creole village known for its shipwrights. After Grand-Gaube, the coastal route is pretty, but becomes narrow and hazardous. A better choice would be to drive through Goodlands (a large Hindu town with, among other attractions, craftsmen making lovely model boats), and from there, to Poudre d'Or, another typical Creole village. There is a monument commemorating a shipwreck, that of the Saint-Géran, in August 1744, in the seas off neighbouring Ambre Island. See the 19th-century hospital, the restored Anglican chapel next to the sea, and the pleasant Sainte-Philomène church (1846), renamed Marie-Reine. Conclude your journey with a detour to Pointe-des-Lascars, at Rivière-du-Rempart. Enjoy the seaside at Roches Noires, where you can explore the cave, and the town of Poste-Lafayette.

4. THE ROMANTIC NORTH

Drive out of Port-Louis in the direction of Vallée-des-Prêtres, the hamlet so well depicted by Bernadin de Saint-Pierre in his novel, *Paul and Virginie*. It has lost none of its charm. After a brief visit, you branch off to the right towards Cité La Cure and Sainte-Croix (see the itinerary for **The North Coast**). This takes you, via Terre-Rouge, towards Montagne-Longue, an appealing village where the market is shaded by fruit trees. Take a look at its nicely old-fashioned, colonial-era hospital.

The road takes you into the 18th-century capital town of the canton, Valton. The villages of Ruisseau Rose (with its former mineral springs) and Crève-Coeur, offer a harmonious blend of mountains, abundant vegetation, the unforgettable panorama of the isles to the north, and the friendly local population. Leaving the hills, you can descend towards the northern plains through Îlot, or even better, by les Mariannes

with its banana plantations, and Congomah. In Congomah you will find a village in which the deep Indian roots of Mauritius are very apparent.

At the intersection of the roads B20 and A2 you can stop at Grande Rosalie, Villebague's château. Continue on the road all the way to the Nicolière reservoir. Then, retrace your path towards the Pamplemousses Botanic Garden, for a stroll among 4000 varieties of plants, and lotus and waterlily ponds. Discover the lovely chateau of Mon Plaisir, with its entry gate created for the 1862 exhibition at the Crystal Palace, London. The nearby village centre is dominated by a bell tower and the oldest Catholic church (1756) on the island. Its presbytery dates from before 1743. Pay a brief visit to the historic cemetery, where Monsignor Buonavita, Napoleon's last chaplain on the island of Saint Helena, is interred.

A fascinating visit can be made to The Sugar Adventure, an interactive museum of the sugar industry, installed in the former sugar factory at Beau-Plan. As you drive along the Arsenal road, your exploration might continue at the old leper colony at Moulin-à-Poudre, the Asile forest, or the Ehelepola monument, commemorating a Sri Lankan prince who was exiled to Mauritius in 1825. After Arsenal and the junction with the B29, return to the romanticism of Mauritius long ago with a stop at Goulet, the beach at Baie-du-Tombeau. It was here, in *Paul and Virginie*, that Bernadin de Saint-Pierre set the discovery of the unfortunate Virginie's corpse.

5. AROUND THE MOKA MOUNTAINS

Leave Port-Louis, taking the Port-Louis to Réduit highway. First stop is the les Pailles estate (see the itinerary **Port-Louis by Car**), in Anse Courtois, at the foot of the Pouce mountain. Exit the highway at the Montagne-Ory bypass. Visit the Eurêka house and its souvenirs of old Mauritius. Heading towards Moka, take the Bois-Chéri road, offering superb views of the Pouce. At Saint-Pierre, take the B49, passing through villages with evocative names like Beau-Bois, Ripailles, and Nouvelle Découverte. Take the road running parallel to the mountains; you will find yourself near les Mariannes and Montagne-Longue. Then you can go on to Port-Louis.

In Port-Louis take the highway to Pamplemousses, then the Magon Road and Victoria Avenue as far as the Champs-de-Mars. End the excursion on the Dauguet leisure promenade.

6. MAURITIUS EAST

From Saint-Pierre, take the A7 towards Quartier-Militaire, then the B27 towards Montagne-Blanche. At Melrose, visit the Sans-Souci Greenhouses, with an interesting collection of ferns, cacti, and other decorative plants. At Montagne-Blanche, a detour on the way to Sans-Souci leads to one of the main sugar factories from the period between the two World Wars. Another interesting detour is Sébastopol, a village with the ruins of an old sugar factory of the same name. You rejoin the B27 just before Belle-Rive or Kewal Nagar, the village birthplace of Sir Seewoosagur Ramgoolam, the first Prime Minister of independent Mauritius. A leisure promenade, theme park and vacation village are being built at the Étoile estate at Belle-Rive.

Next is Deep River/Pont Lardier, formerly known as Trois-Îlots, which, up to the 19th century, played an important part in local administration, religion and agriculture, including tea cultivation. Bel-Air/Rivière-Sèche has a large church with two imposing towers, visible from a great distance. In the 19th century, Father Dorbec, the parish priest, put his personal fortune into this ambitious building project. At the exit from Bel-Air, keep to the right until Grande-Rivière-Sud-Est, the former terminus of the Northern Railway, with a ferry service across the river. At the river is a lovely waterfall best admired from a boat.

Return to Bel-Air on the B28, and take a right towards Trou-d'Eau-Douce, the departure point for Deer Island (see pp. 26-29). From Trou-d'Eau-Douce, follow the coastal road until Poste-de-Flacq, passing Palmar and Belle-Mare. Some of the most beautiful hotels on the island sit amidst unforgettable beaches and views of shimmering jade- and emerald-coloured lagoons. A special mention must be given to the Saint-Geran and Prince Maurice hotels at Belle-Mare and Poste-de-Flacq, and the golf course of the Belle-Mare Beach Hotel. At Belle-Mare, see the interesting ruins of the Belle-Mare sugar factory, the first on the island (early 18th century) to have a steam-powered sugar-cane mill. Poste-de-Flacq has an 18th-century bakery, an 1864 church dedicated to Saint Maurice, and a brilliant white Hindu temple, built on a small guava island in the middle of an inviting lagoon.

You reach Centre-de-Flacq by Argy and Riche-Mare, with vestiges of the 19th-century sugar industry. Have a look at the villages of Clémencia, Camp-de-Masque-Pavé, and Queen Victoria, and the church and cemetery of Saint-Julien.

7. EXPLORING GRAND-PORT

Cross the imposing bridge to Grand-Rivière-Sud-Est. The coast road passes through the seaside villages of Deux-Frères, Quatre-Sœurs, and Grand and Petit-Sable. Along the coast, fishing villages alternate with fields planted with vegetables. The Diable battery, a coastal fort dating from the French colonial period, was refurbished during the Second World War.

Compasses seem to act abnormally or 'devilishly' just offshore here, hence the name given to the fort. The restaurant Le Barachois deserves a stop. It is constructed from the increasingly rare ravenal palm, used in times past for makeshift shelters. Take the road to the right, leading to Ylang-Ylang (perfume manufacturing) and Chasseur, which is worth a full day's visit. Bois-des-Amourettes sounds like a truly romantic place, but it is more probably named after the similarly named liana plant. Stop about a hundred metres before the local police station to admire Lion Mountain from a different perspective.

At Vieux-Grand-Port, the elegant, modern church has a wooden statue of Notre-Dame-du-Grand-Pouvoir, which may have been scavenged from a shipwreck. Archeological excavations here are revealing the location of ancient French fortifications, which themselves were built on top of 17th-century Dutch buildings. The Friederich Heinrik Museum, named for Maurice de Nassau's brother, and the name of the early Dutch settlement, explains prominent events of Mauritius' Dutch colonial period, and displays 18th-century items discovered at the site. Not far away is the Salle d'Armes, a cave in the coral cliffs. According to legend, duels that were forbidden in public were held here. In Ville-Noire, near Ruisseau-des-Délices, visit the manioc cake factory. The Rault and Sénèque families have made these cakes for over 100 years, according to a traditional recipe handed down from generation to generation.

In Mahébourg there are many places to see: the Cavendish-Boyle bridge over the La Chaux River, Pointe-Canon which honours the freed slaves, Pointe-des-Régates (a monument to the sailors and soldiers who died during the naval battle of Grand-Port, and a view of tiny Mouchoir-Rouge island), the new seaside promenade, artisans' stalls, the newly renovated fishing wharf, ruins of the old railway station, an early 19th-century wash-house and drinking trough, a 19th-century hospital built on the site of ancient military barracks, the history museum in the old Gheude/De Robillard château (lodging for officers injured during the naval battle of August 1810), and the mid-19th-century Notre-Dame-des-Anges church. Extend your journey to Blue Bay to see its very beautiful marine park.

8. THE WILD SOUTH

From Mahébourg take the A10 towards Plaine-Magnien, then the B8 towards Escalier. Before arriving at Escalier, visit the coastal village of Bouchon, where a natural bridge links basalt cliffs, far above the waves. At the place known as Souffleur, waves penetrate the winding spaces between the rocks, creating a geyser and a booming sound that can sometimes be heard from kilometres away. Continue your drive until Rivière-des-Anguilles, stopping at Bénarès (an old sugar factory ruin), at Senneville (the Vanille Nature Park, with an impressive collection of 20,000 types of butterflies and insects, a nursery for 300 giant Aldabra tortoises, crocodiles, monkeys, and pigs).

Take the A9 to Souillac. Stop at the Saint-Aubin estate and dine in a beautiful 18th-century colonial home with vanilla gardens, anthuriums, and a rum distillery where the rum is made, not of molasses, but of sugar cane juice or 'fangourin'. In Souillac, visit the untamed beach and cliffs of Gris-Gris, Nef (a literary museum built on the site of the poet Robert Edward Hart's coral house), Telfair Garden, the police station (an early military post under renovation), the 19th-century bathhouse, the mid-19th-century Saint-Jacques church, the Rochester waterfall, Batelage (home port for the enormous barges which carried sugar to Port-Louis), the remains of the old Surinam sugar factory (just after the bridge over the Savannah River), the sailors' cemetery and Cemetery Point. The coastal road between Riambel and Bel Ombre is being improved because of the many new hotel projects under way (a dozen high-class hotels, golf courses, and luxurious villas). A visit is recommended to Sanchez, a tiny coral island.

Baie-du-Cap has been spruced up to mark the bicentennial of the arrival here of celebrated British explorer Matthew Flinders on 15 December 1803. He sailed from Australia aboard the *Cumberland*, a 50-ton schooner that measured only eleven metres (36 feet) in length. A monument honouring Flinders will join another commemorating the shipwreck of the *Trevessa* in June 1923. Two of its lifeboats carrying 34 men made their way to safety at Baie-du-Cap and Rodrigues, after 25 days at sea with no compass and limited rations. Sailors all over the world celebrate Trevessa Day in memory of their colleagues lost at sea. Stop to admire the Rivière-du-Cap estuary, one of the most beautiful views in Mauritius. There is a public beach at Prairie. You will soon reach Morne Brabant, a fabled mountain that has inspired poets and artists, and is considered sacred by many. Long ago, many fugitive slaves found refuge among its cliffs, throwing themselves off when threatened with capture. Finally, reach Morne, the birthplace of the Mauritian tourist industry.

9. THE BLACK RIVER COAST

From Port-Louis, head south. At Grande-Rivière-Nord-Ouest don't miss: the Sables Noirs public beach, Breton cemetery, Saint-Louis tower (French coastal defense), Koenig Tower (remains of a lovely 19th-century residence). At Terrason: a

Martello tower, Pointe-aux-Sables, Petit Verger. Albion: the lighthouse at Pointe-aux-Caves. Bambous: a 19th-century church, the reservoir, a view of Corps-de-Garde and Saint-Pierre mountains. Flic-en-Flac: visit the Anna Garden estate, the public beach, Wolmar's wonderful hotels. Cascavelle: a typical Marathi village with a temple and ashram. Casela: an aviary and view of the Rempart mountain. Take a detour if possible to see Yémen. Tamarin: view of the estuary, a 19th-century bridge, a public beach favoured by surfers, a bay frequented by dolphins, and marshes. Carlos: panoramic views of the Rempart mountain and Morne. Black River: another Martello tower, a sport fishing centre, the Saint-Augustin church (mid-19th century), the Black River Gorges National Park (walk along a

tropical river at the bottom of a narrow valley). La Gaulette: arrange a trip with the local fishermen to visit the island of Bénitiers. The tour ends at Morne.

10. THE SISTER CITIES

At Beau-Bassin: the Balfour Garden (you can see a lovely waterfall and the Thabor diocesan residence), the Anglican Saint-Thomas church and churchyard cemetery. Rose Hill: the town hall or 'Plaza', the Theatre Museum, Montmartre church (pretty example of 1940's concrete architecture), Quorum Gymnasium (built in an old freestone abattoir). Quatre-Bornes: clothing fair in front of the city hall on Thursdays and Sundays. Vacoas: the Gymkhana Club's 18-hole golf course, the former British military barracks, the Serge-Constantin Theatre, the Ramakrishna Mission (temple and ashram).

Take the Magenta Road to the foot of the Trois-Mamelles mountain for a view of the Black River region. Henrietta: view of the Tamarind Falls reservoir, the Sept-Cascades Gorges and the Black River coast. La Marie: a water treatment plant for the Mare-aux-Vacoas reservoir and a monument to the British explorer Matthew Flinders. Mare-aux-Vacoas is an ancient natural lake, transformed into a 25-million-cubic-metre (900-million-cubic-feet) fresh-water reservoir.

At Curepipe: the Comajora ship model factory, les Aubineaux (a beautiful family home from the end of the 19th century, now the Musée du Vieux-Curepipe), town hall (another lovely example of Creole architecture), the Royal College (built to resemble Buckingham Palace, on a smaller scale), the

Monument to the Dead, Currimjee Arcades (an imposing early-20th-century freestone building), the Botanic Garden, Trou-aux-Cerfs (a pedestrian promenade 2.5 kilometres (1.5 miles) long, around a volcanic crater with an exceptional sunset view of the west coast). Under clear skies, it is sometimes possible to see the island of la Réunion, 160 kilometres (100 miles) away.

11. THE CENTRAL HIGHLANDS

Start from the Pétrin intersection, where there are a number of alternative routes.

Walking Tour: Take a right at the intersection, along the Black River Gorges to the Macabé forest, rich in local atmosphere. The Pétrin National Park has a wealth of the oldest native plants, which first appeared on the volcanic lava flows (lichens, mosses, ferns). The more adventurous can go on foot all the way to the Mare-Longue reservoir or climb down the Black River Gorges themselves (as long as you have arranged for a car to meet you at the bottom).

(i) By Car from Pétrin: take a left towards Grand Bassin (Ganga Talao), a sacred lake. Visit the temples. There are many macaque monkeys that are attracted by the pilgrims' offerings. There's an attractive mountain climb nearby. At Bois-Chéri, a tea manufacturer and Tea Museum have a tasting salon where you can try a variety of teas. On a sunny day, there is a panoramic view of the southern coast. Finally, Saint-Aubin (see the itinerary for **The Wild South**).

(ii) By Car from Pétrin: Take the Mares Road to Bassin-Blanc (a volcanic crater filled with water). The drive down the southern coast to Chemin-Grenier is spectacular.

(iii) By Car from Pétrin: Start at the Mares crossroads. Stop at the Alexandra waterfall, for a panoramic view of the Black River Gorges. Have lunch at La Varangue, renowned for its views of the south coast and the indigenous trees in the garden. Chamarel: See the area of Terre-des-Sept-Couleurs and the Adventure Park.

From Chamarel, drive to Baie-du-Cap (the road is not always in great condition) for views of the south coast, or to Case Noyale for views of the west coast and Morne Brabant.

12. THE CENTRAL PEAKS

Beautiful hikes in a region formerly dedicated to tea plantations. Also the Midlands reservoir.

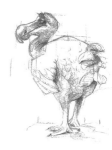